This book belongs to: ___________

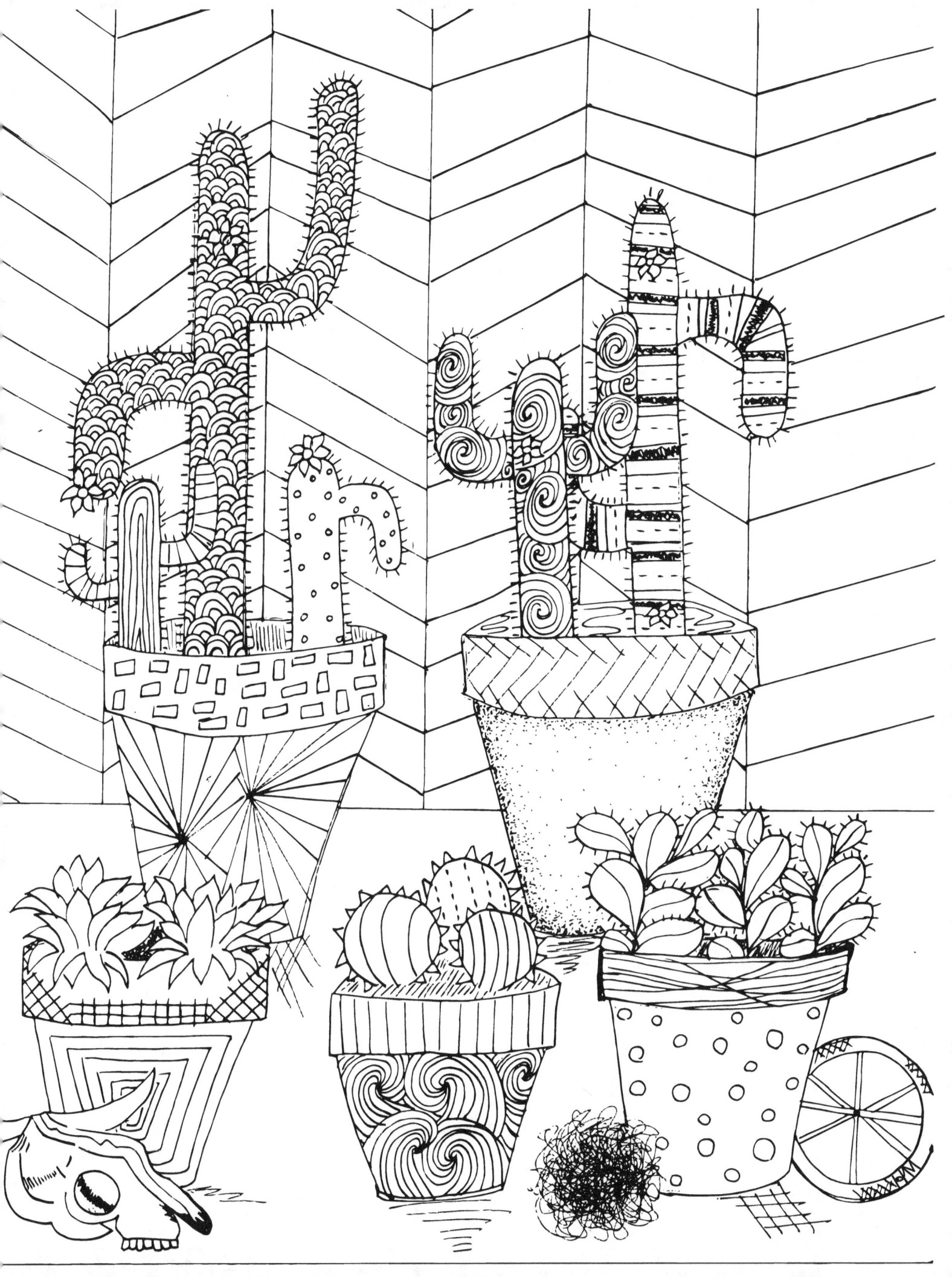

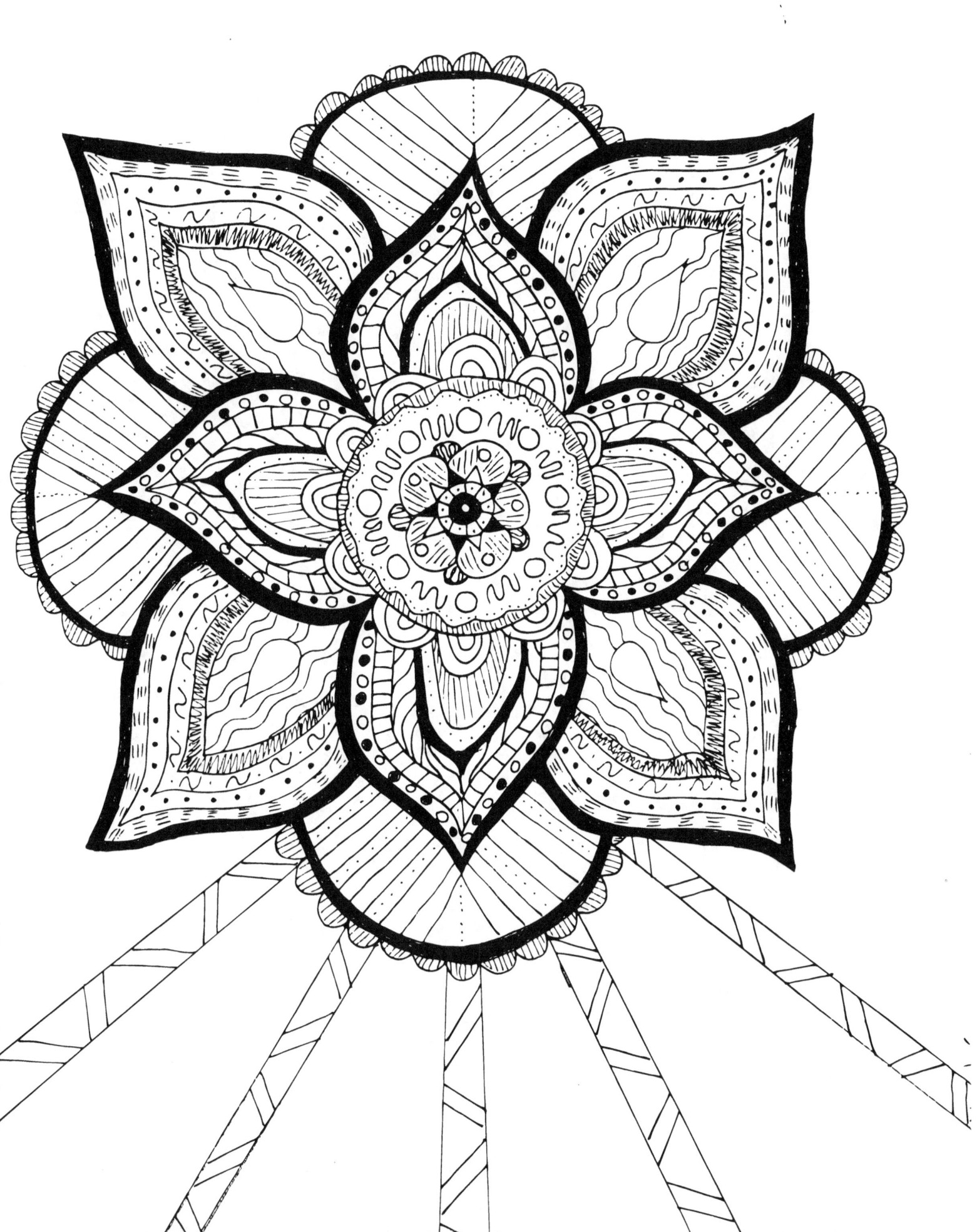

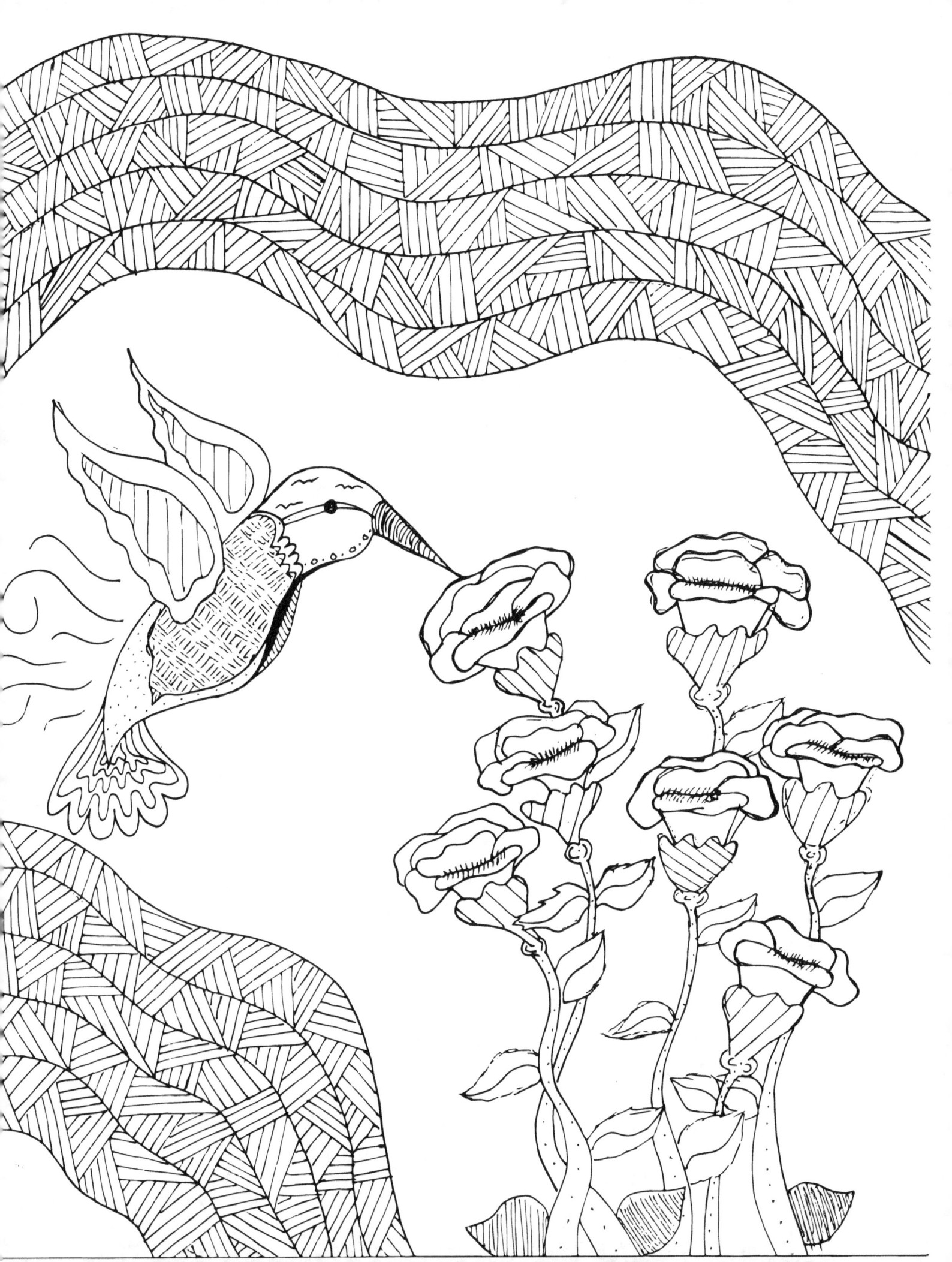

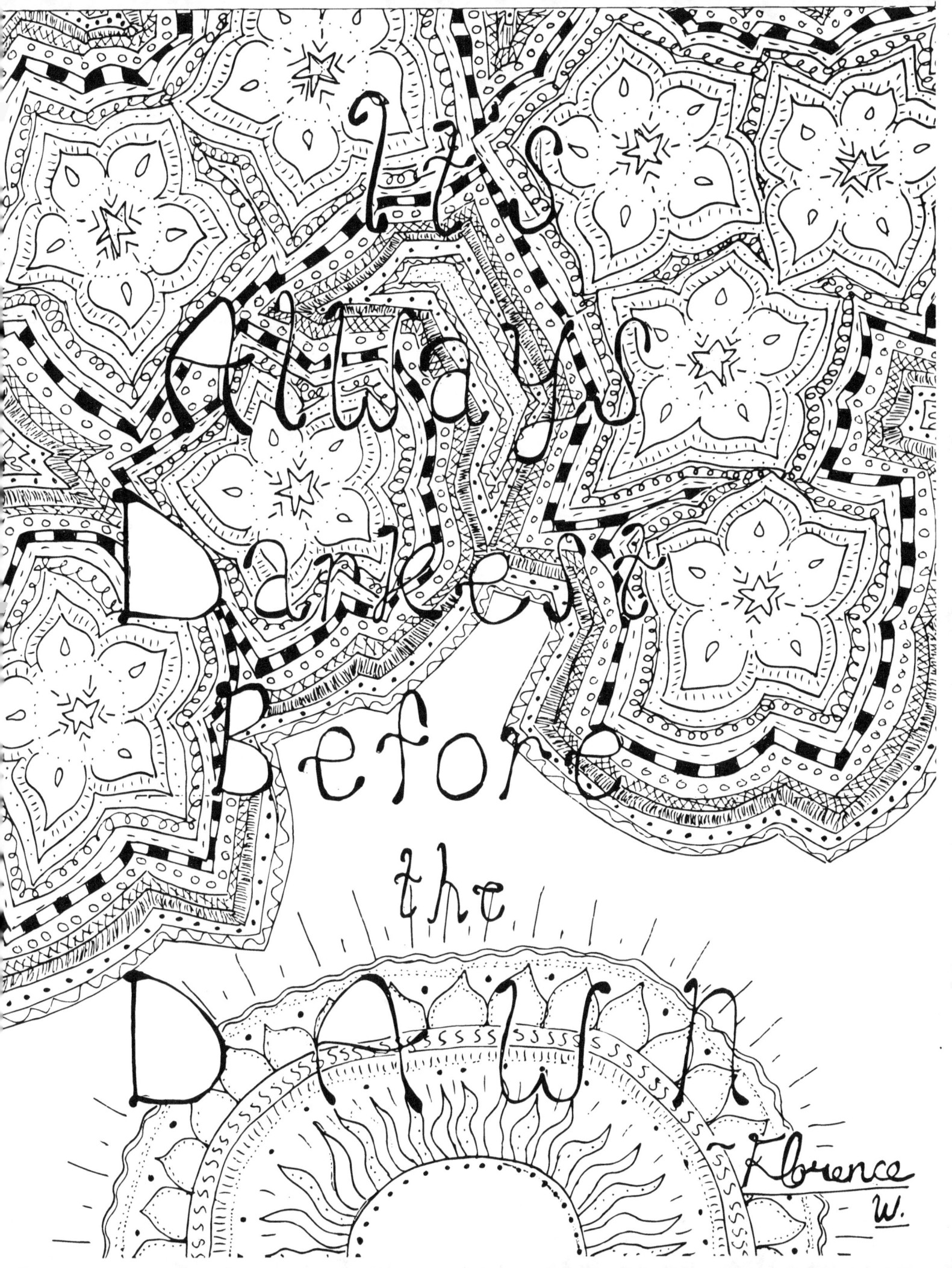

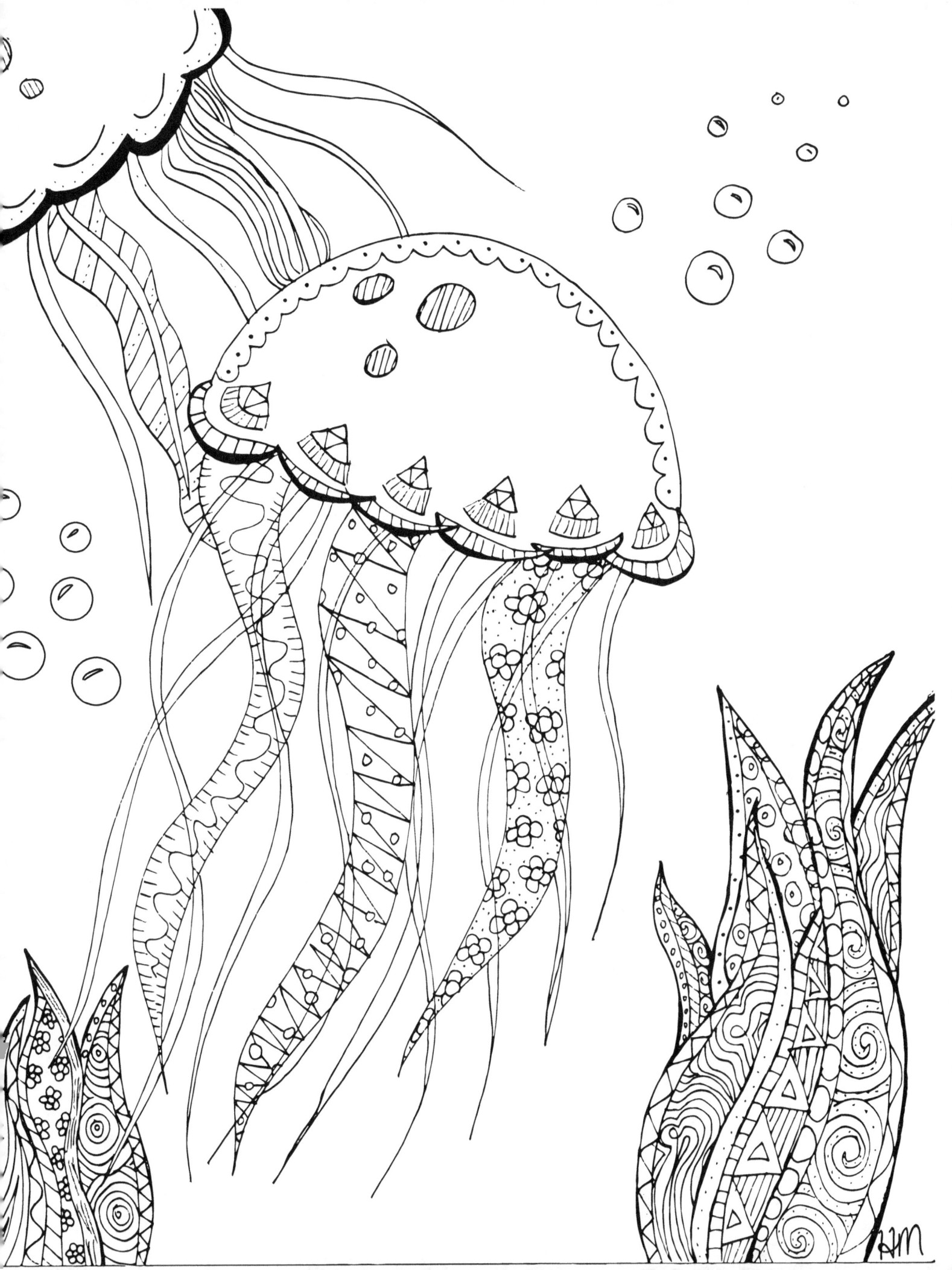

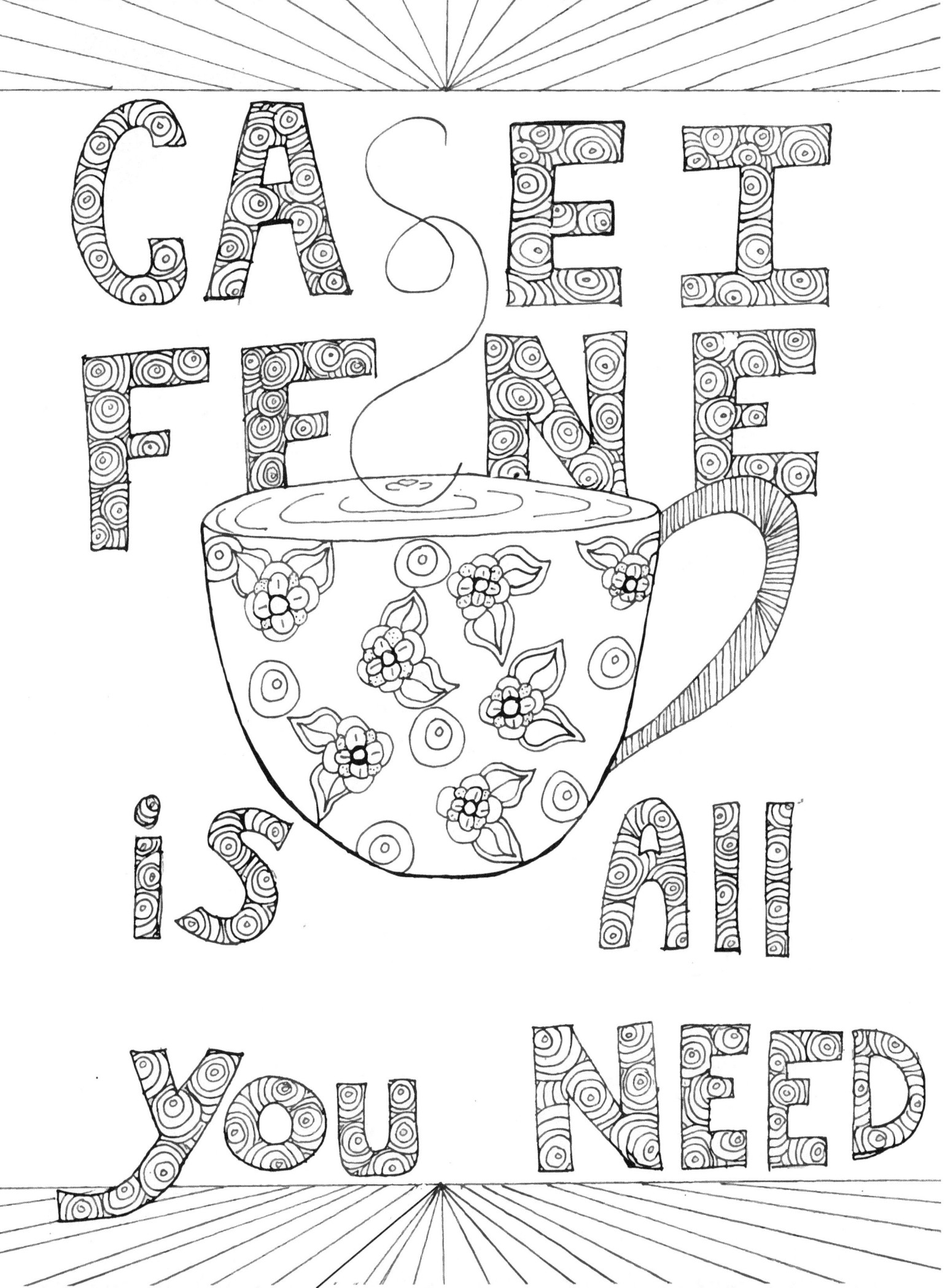

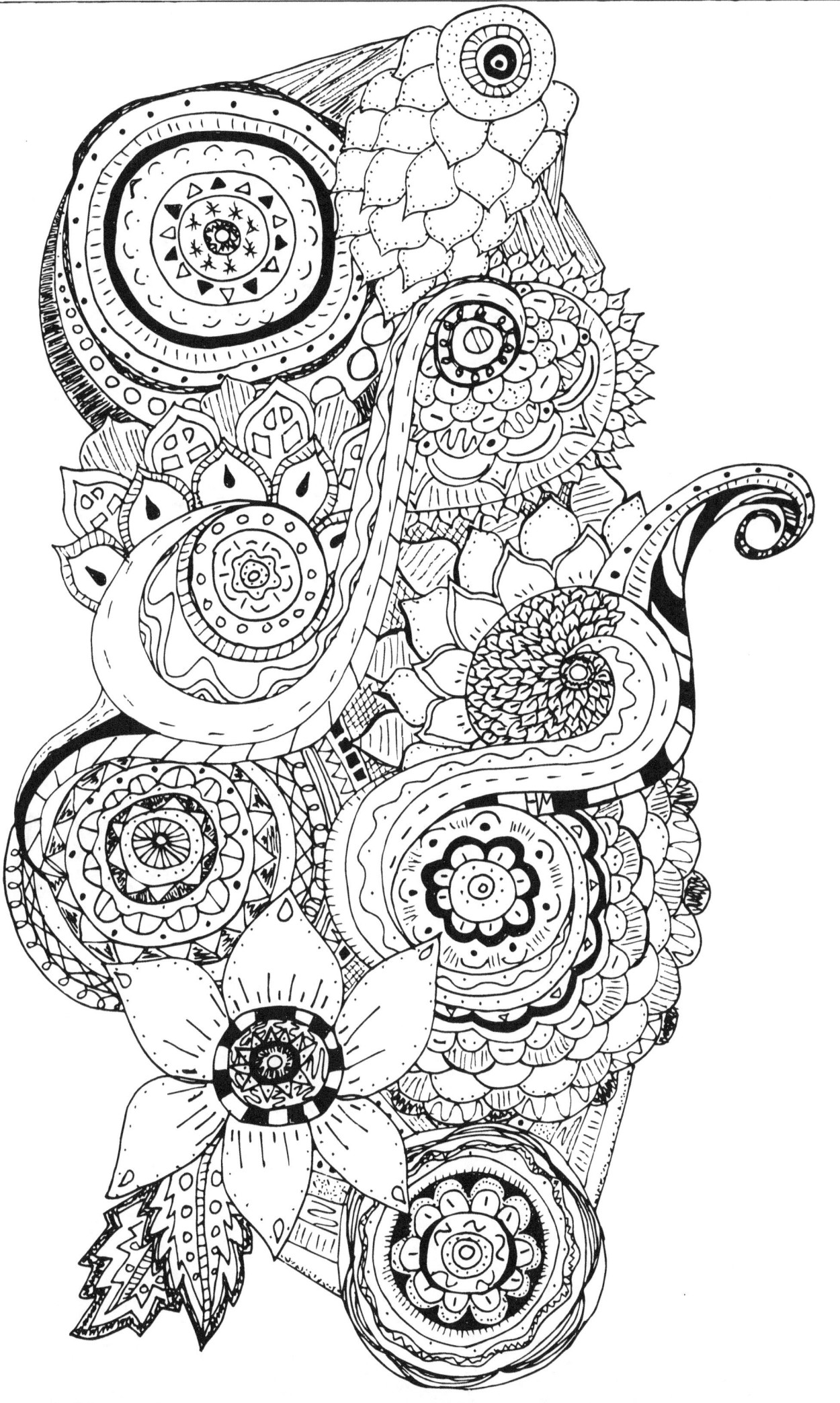

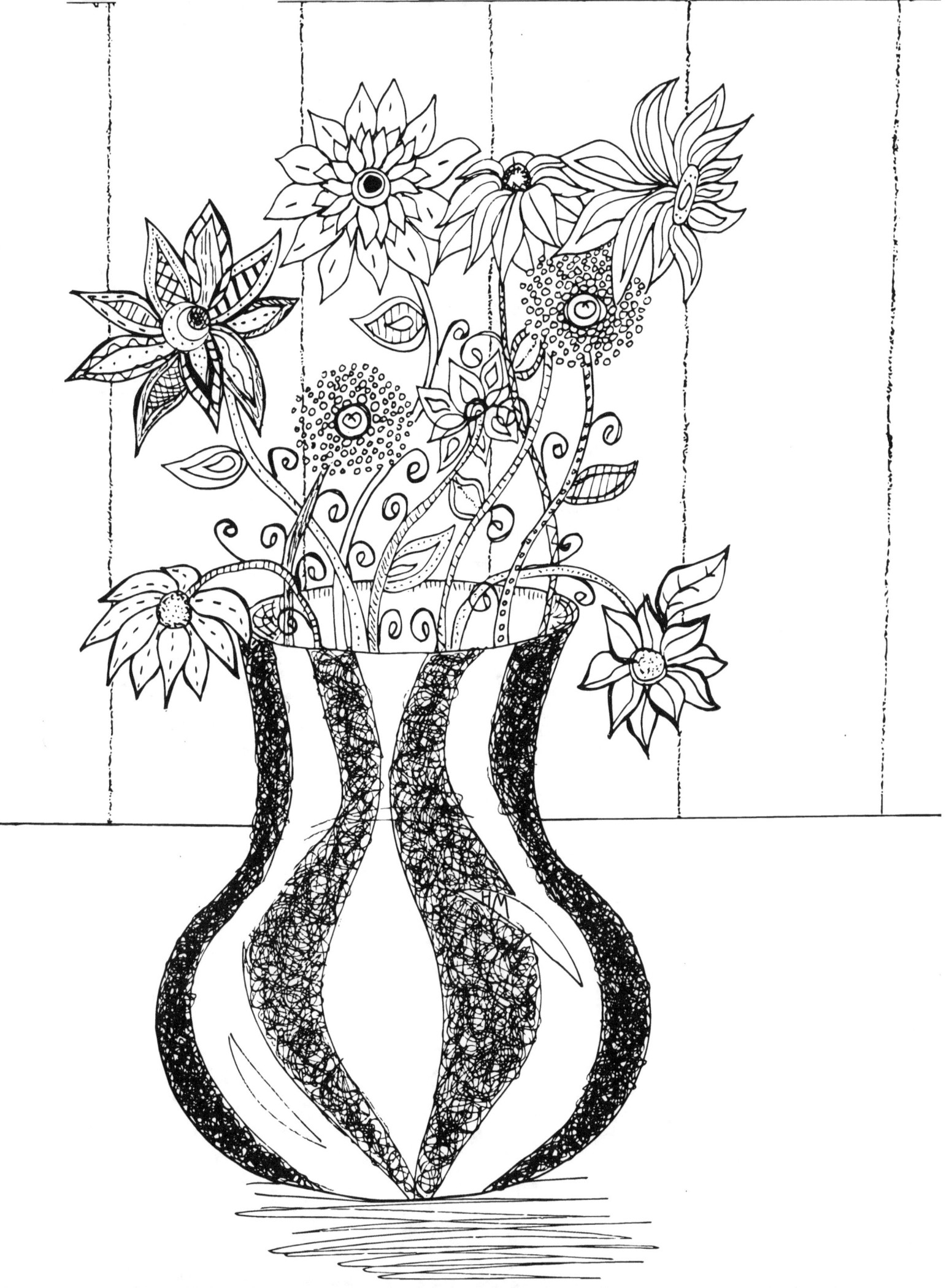

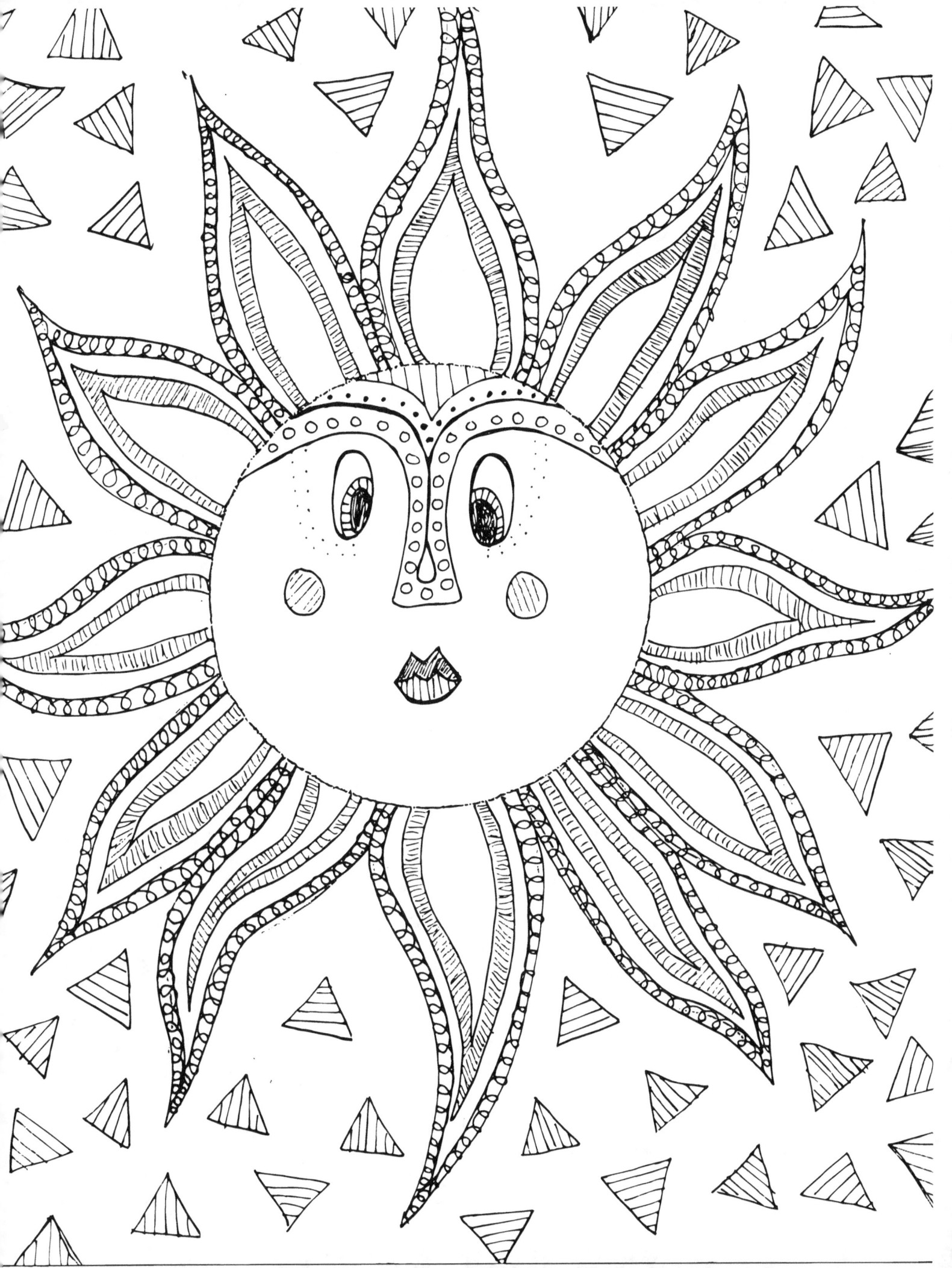

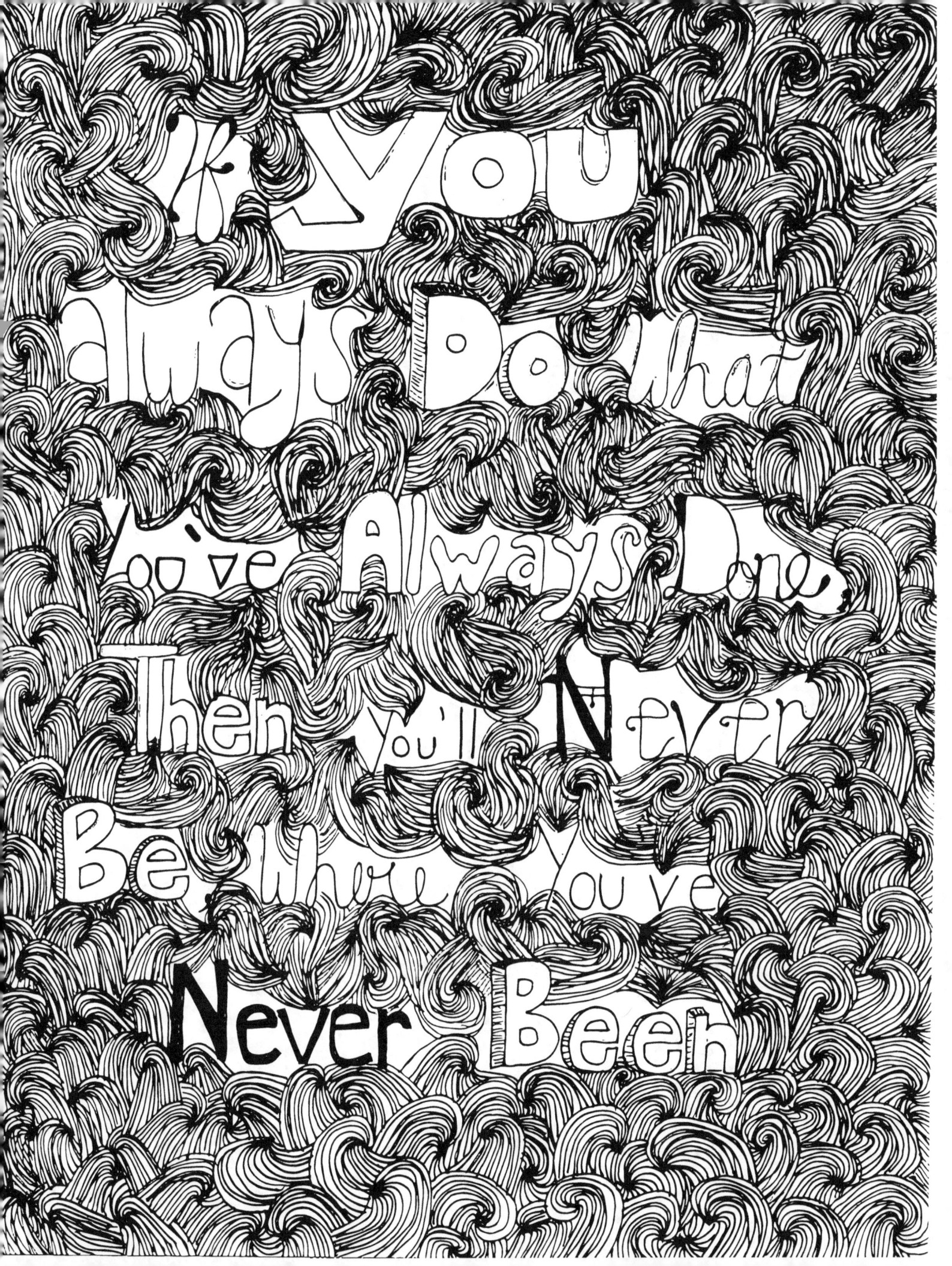

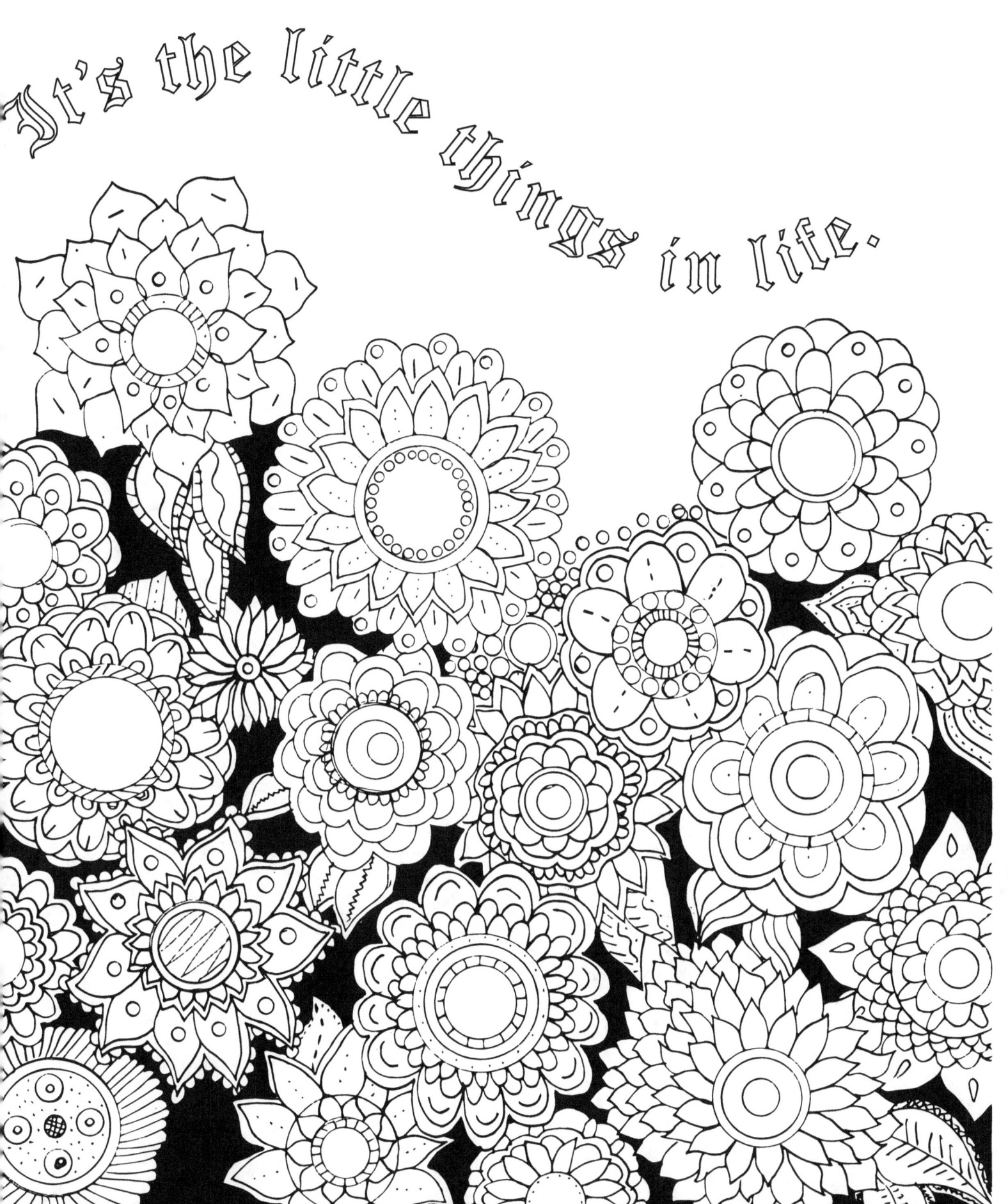

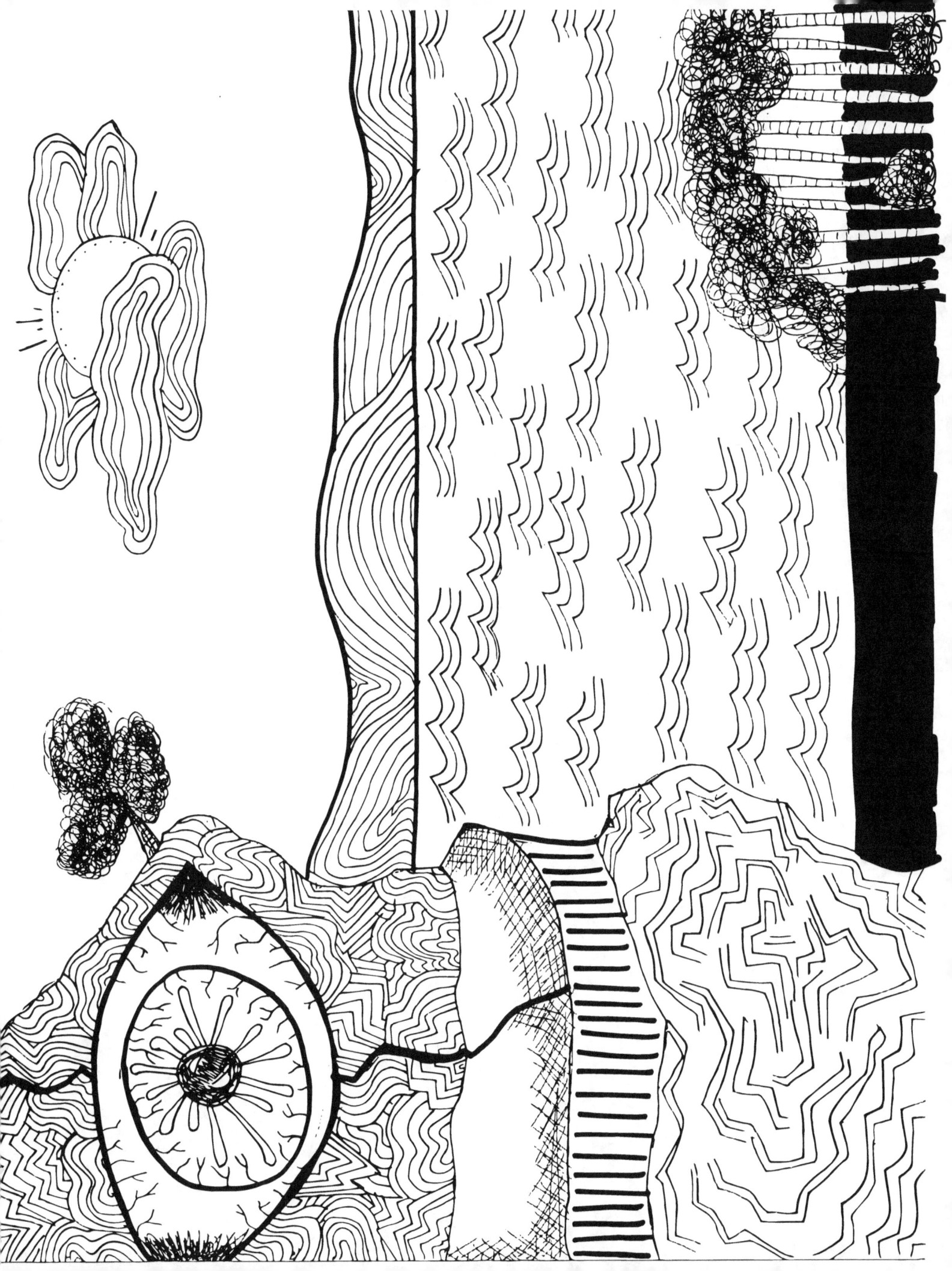

It Always Seems Impossible Until it's Done.

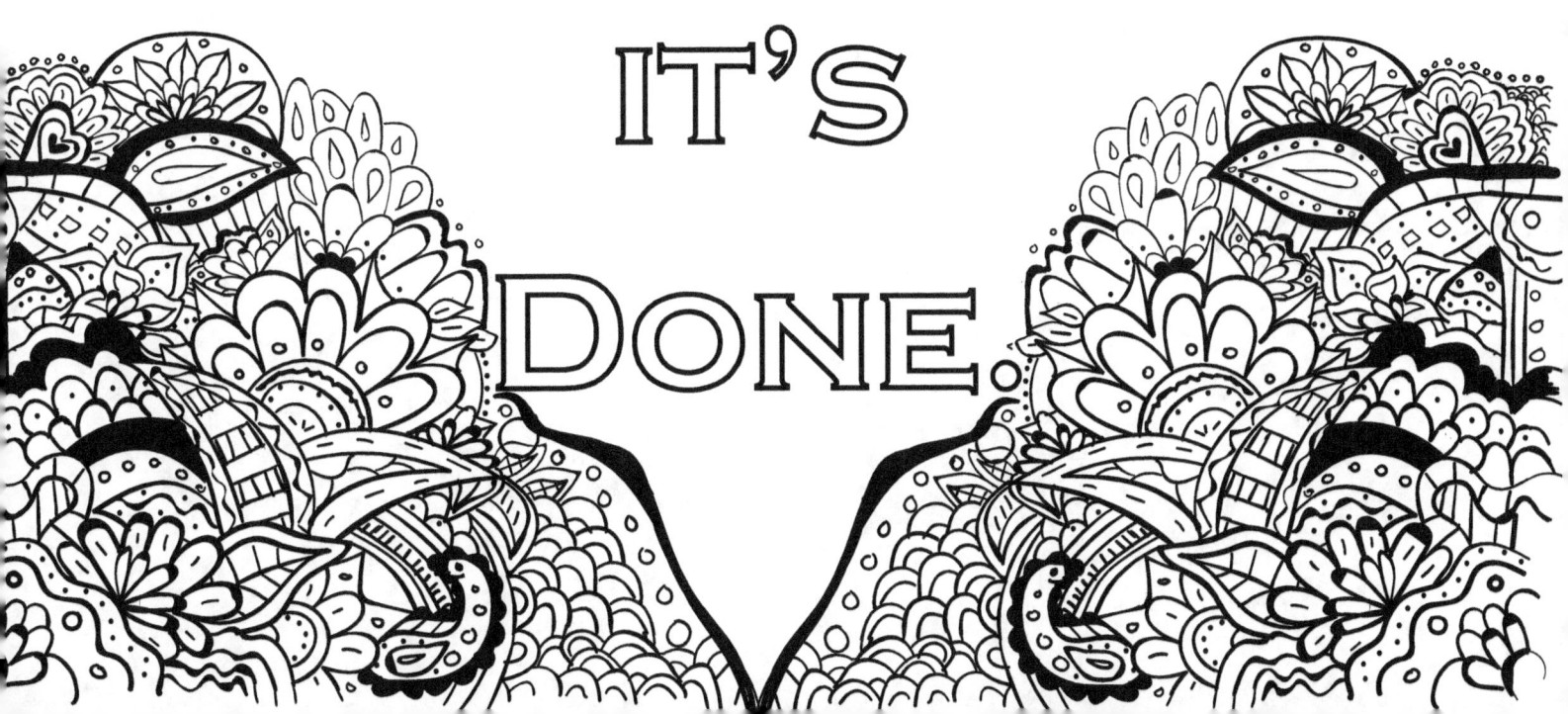

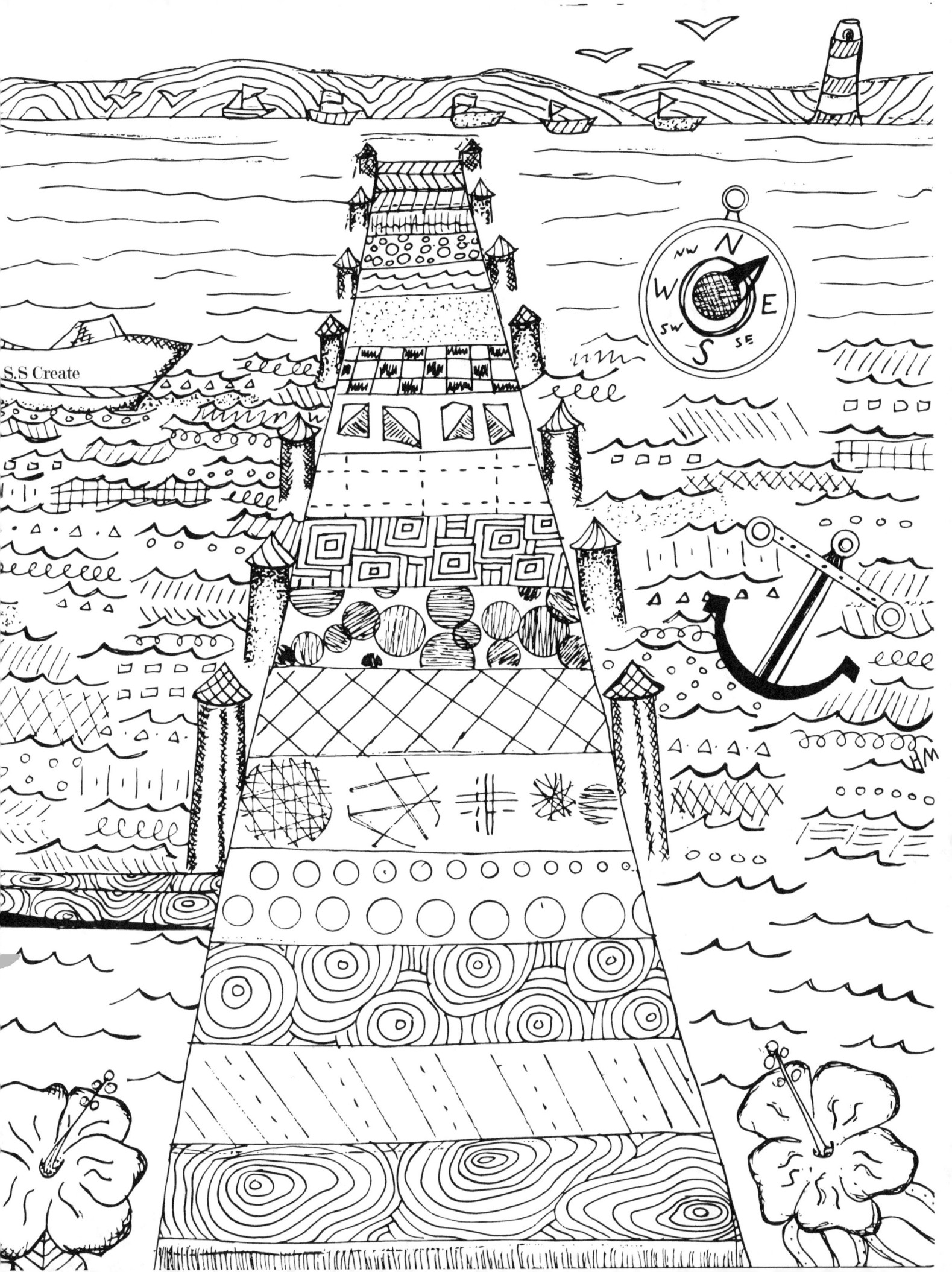

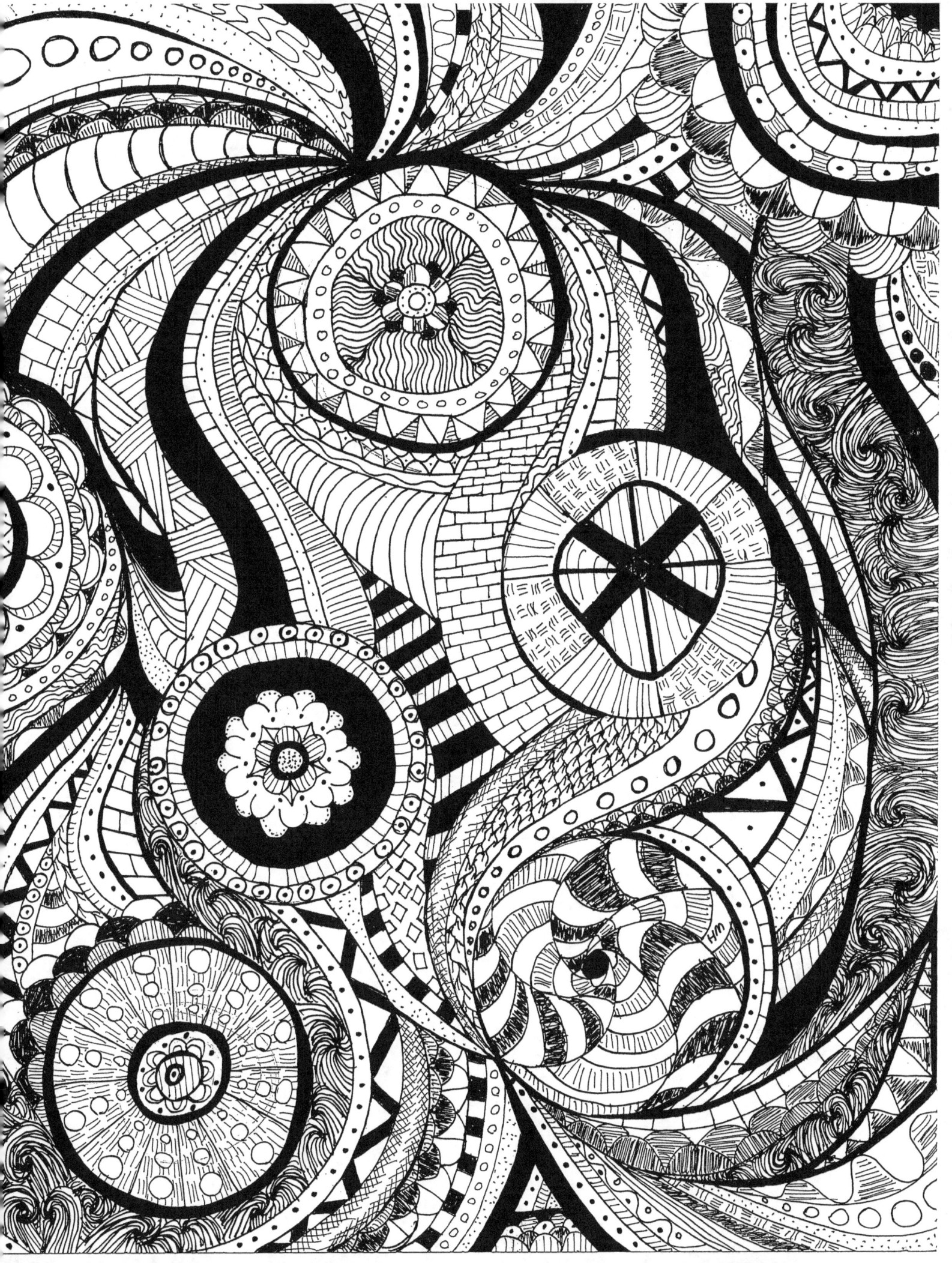

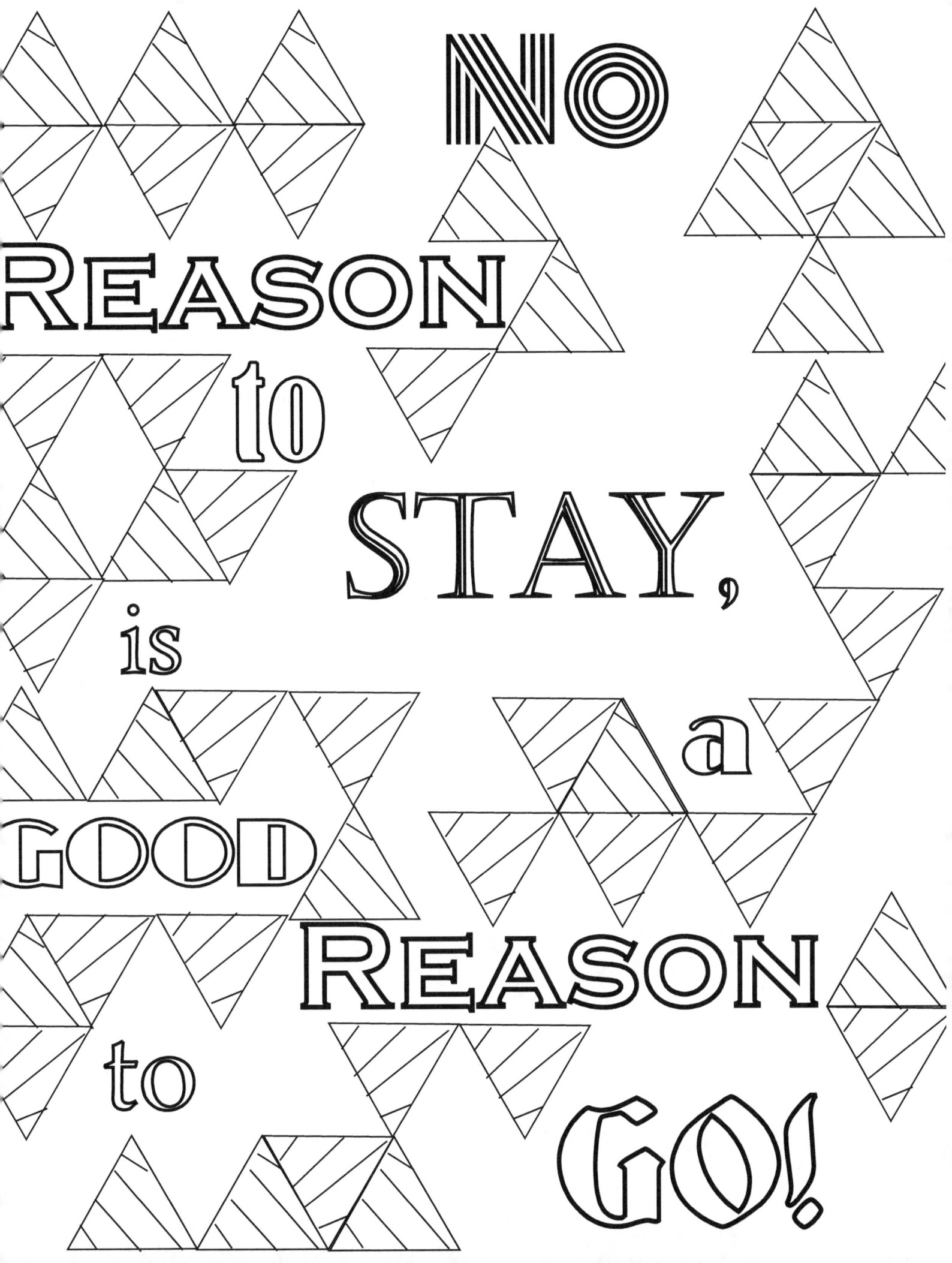

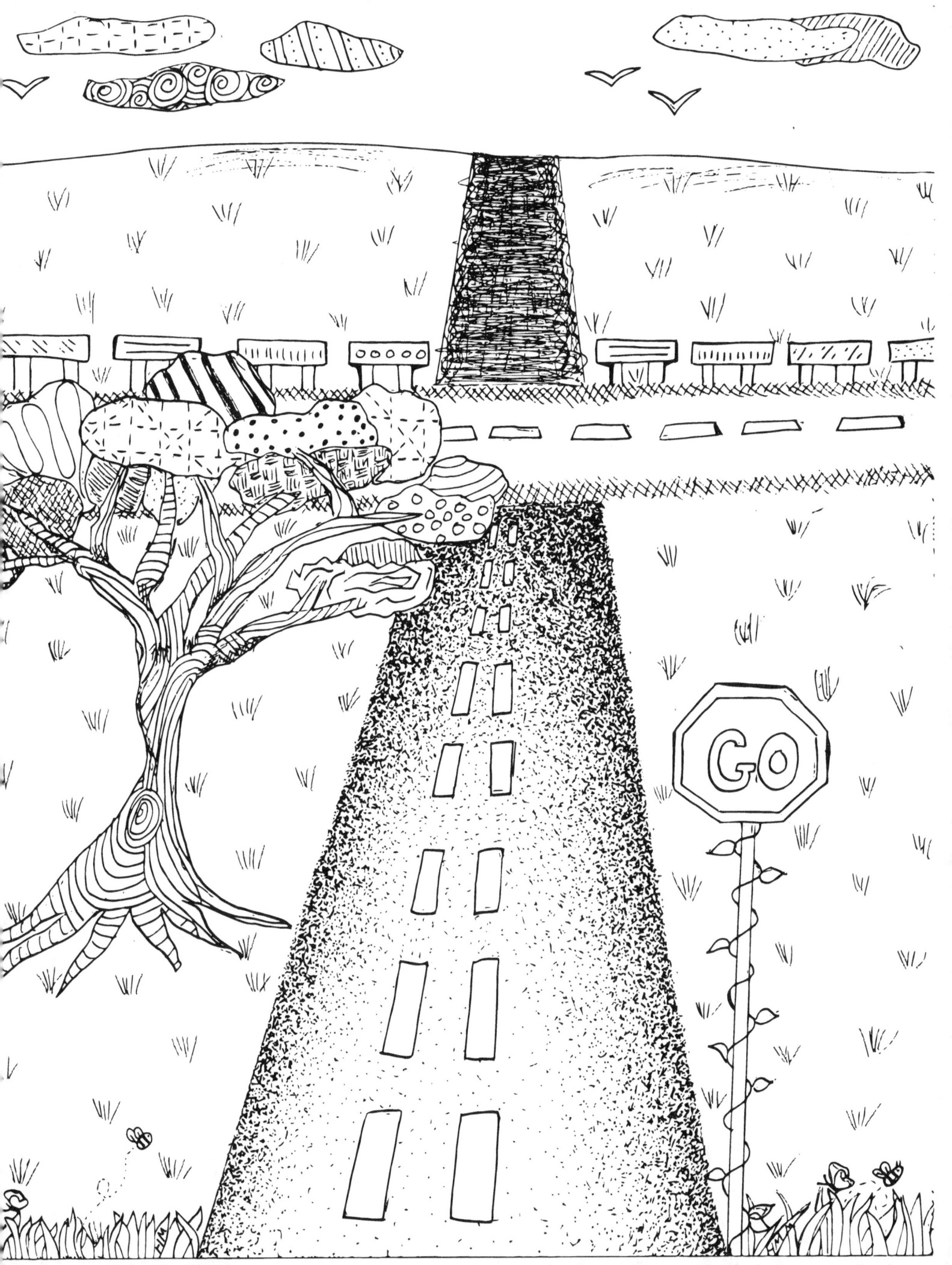

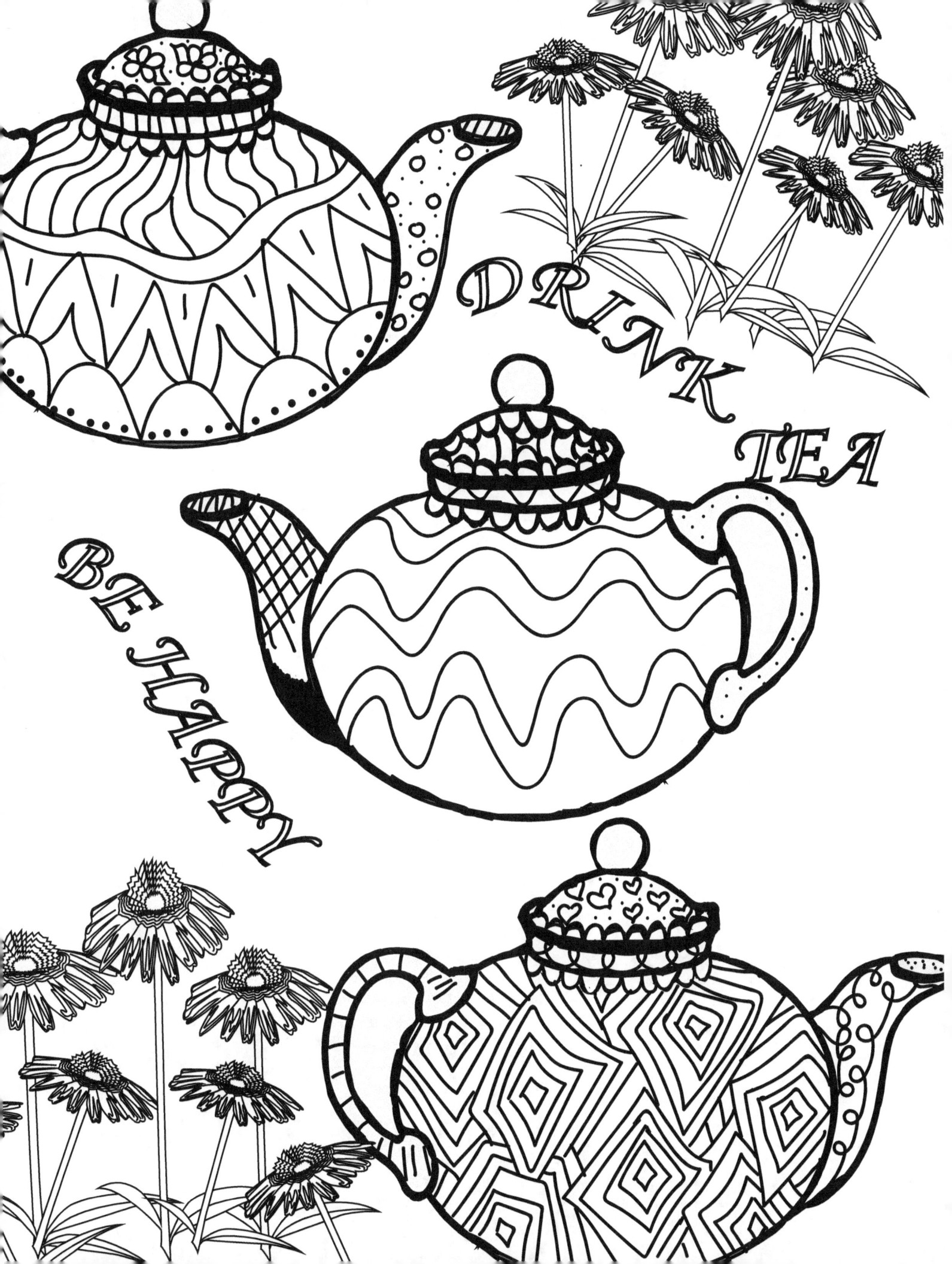

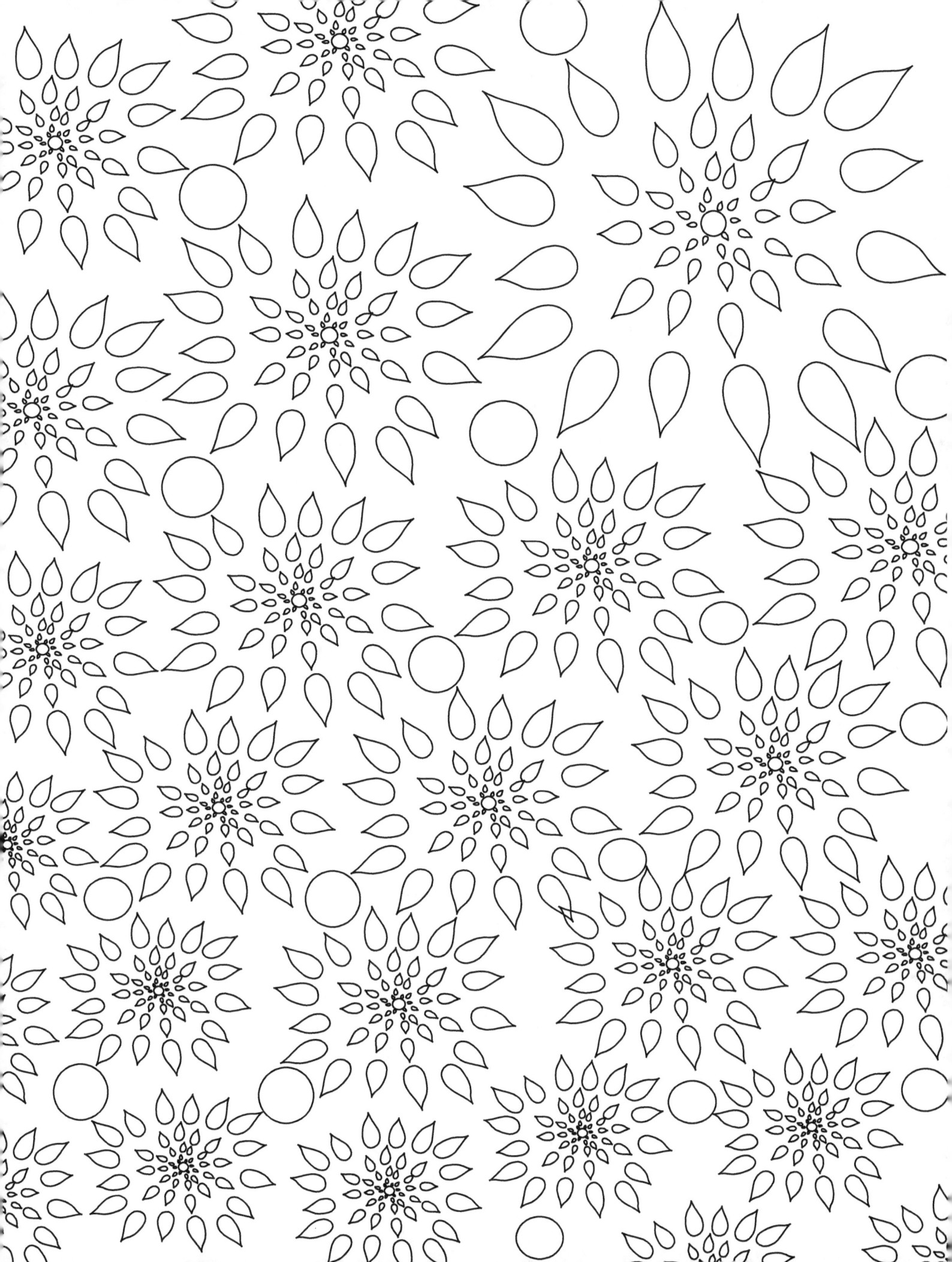

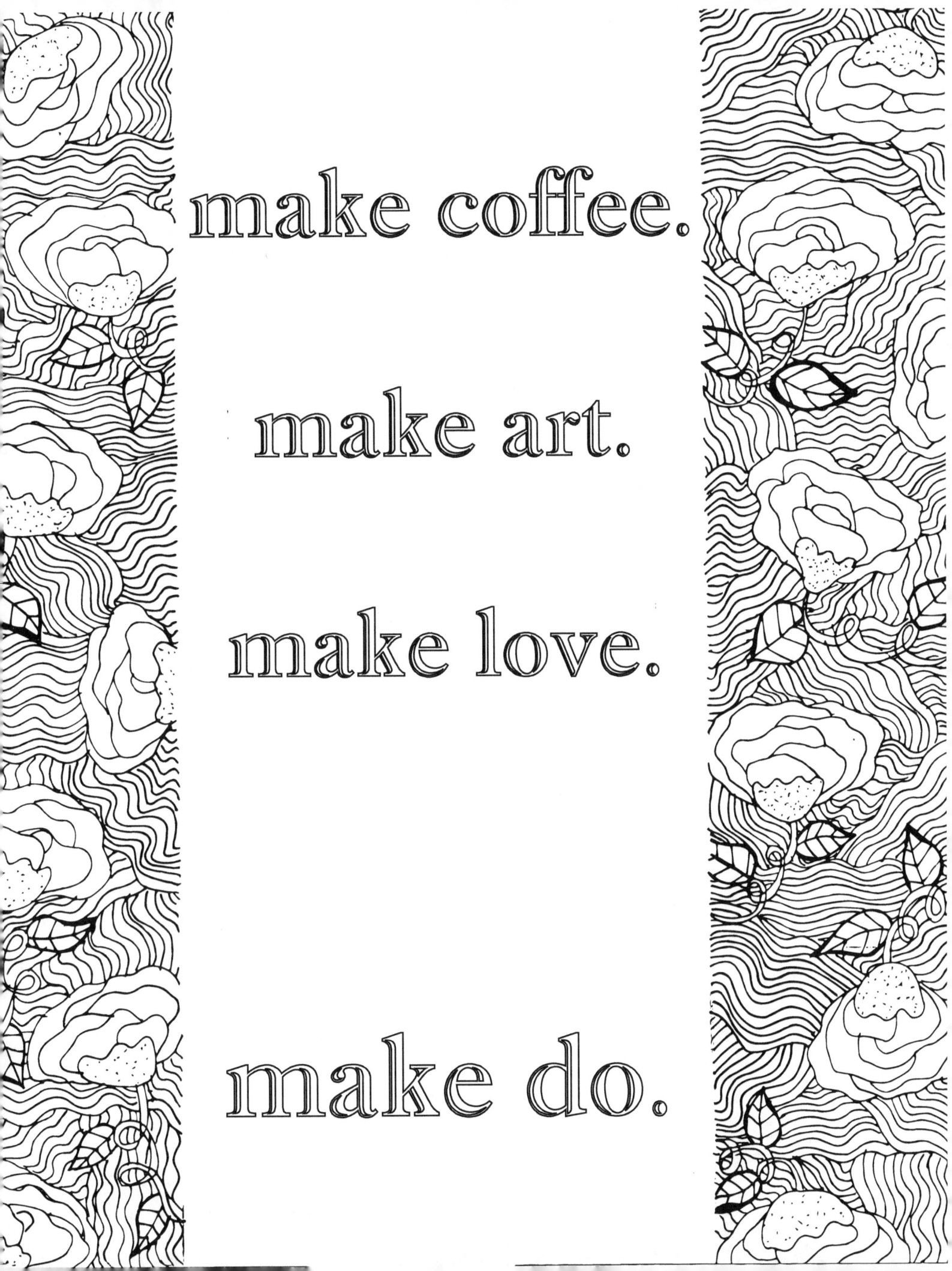

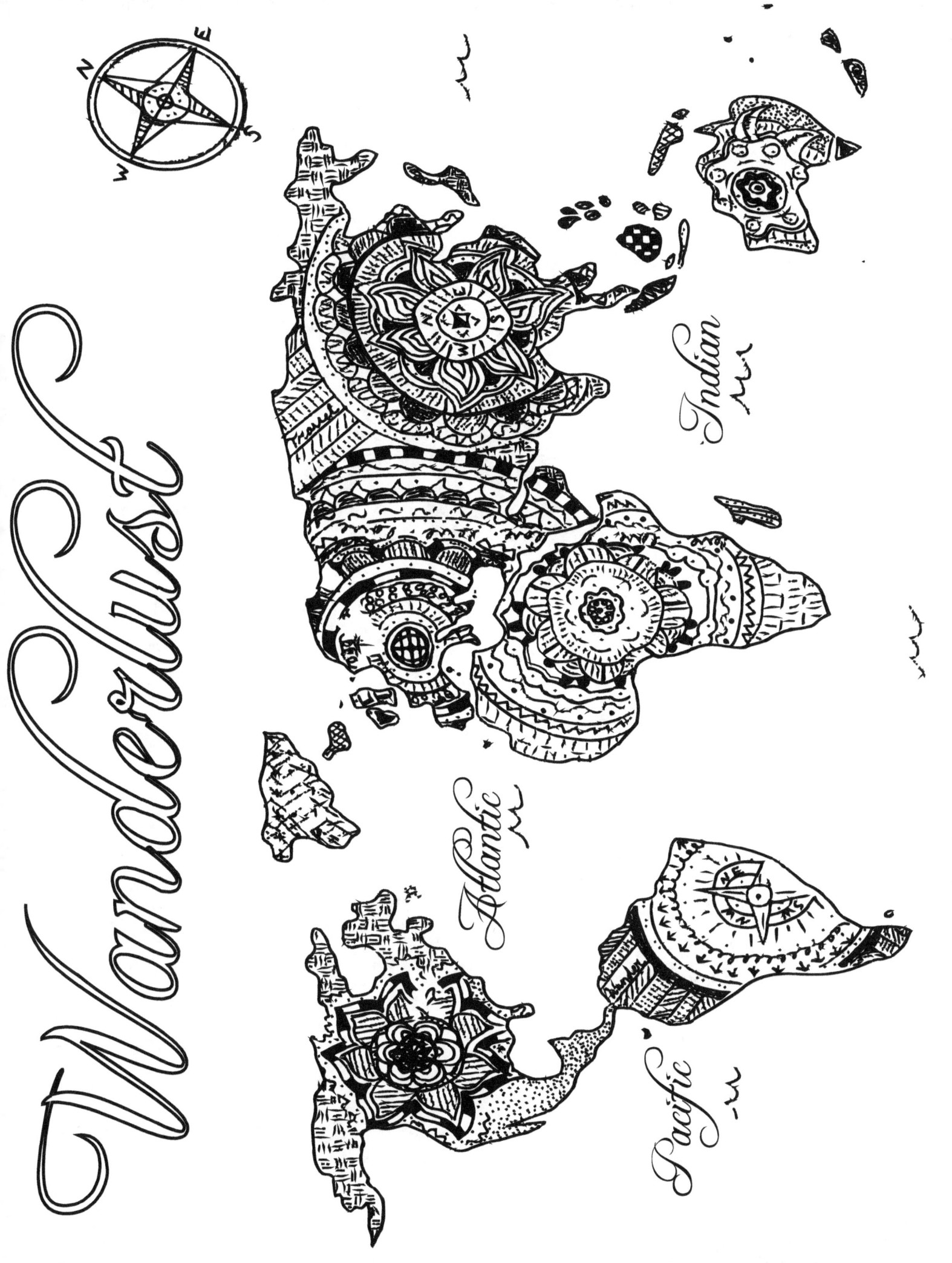

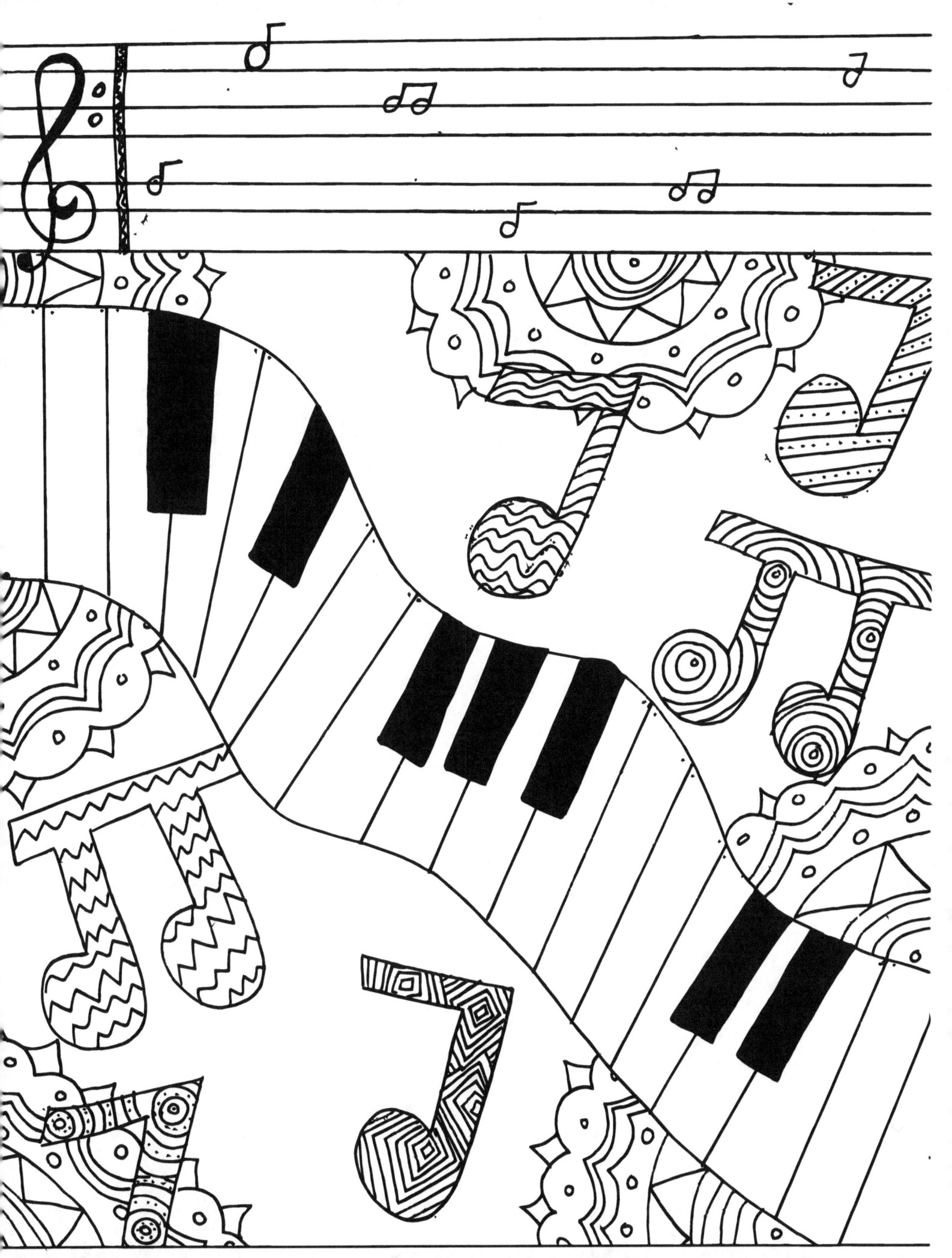

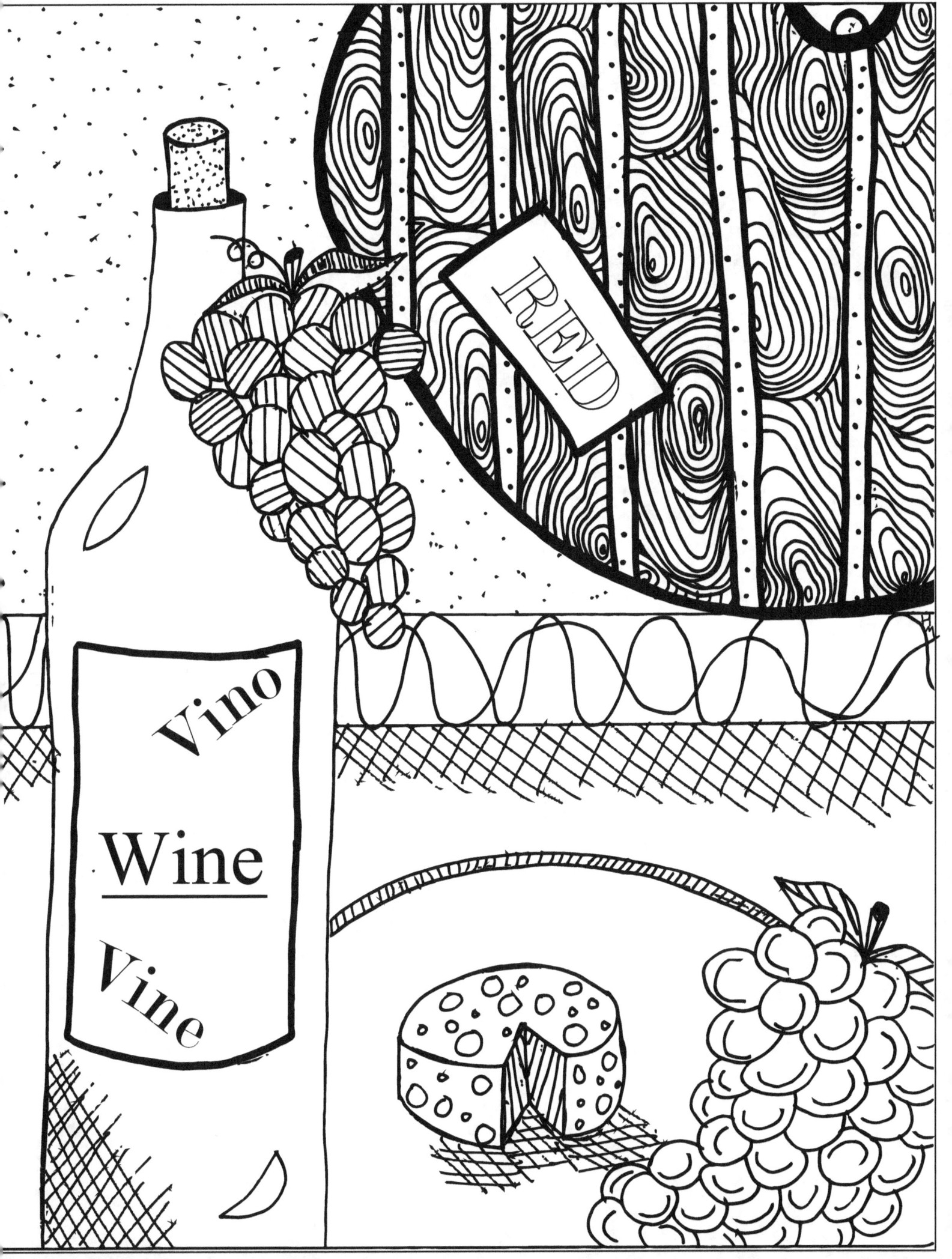

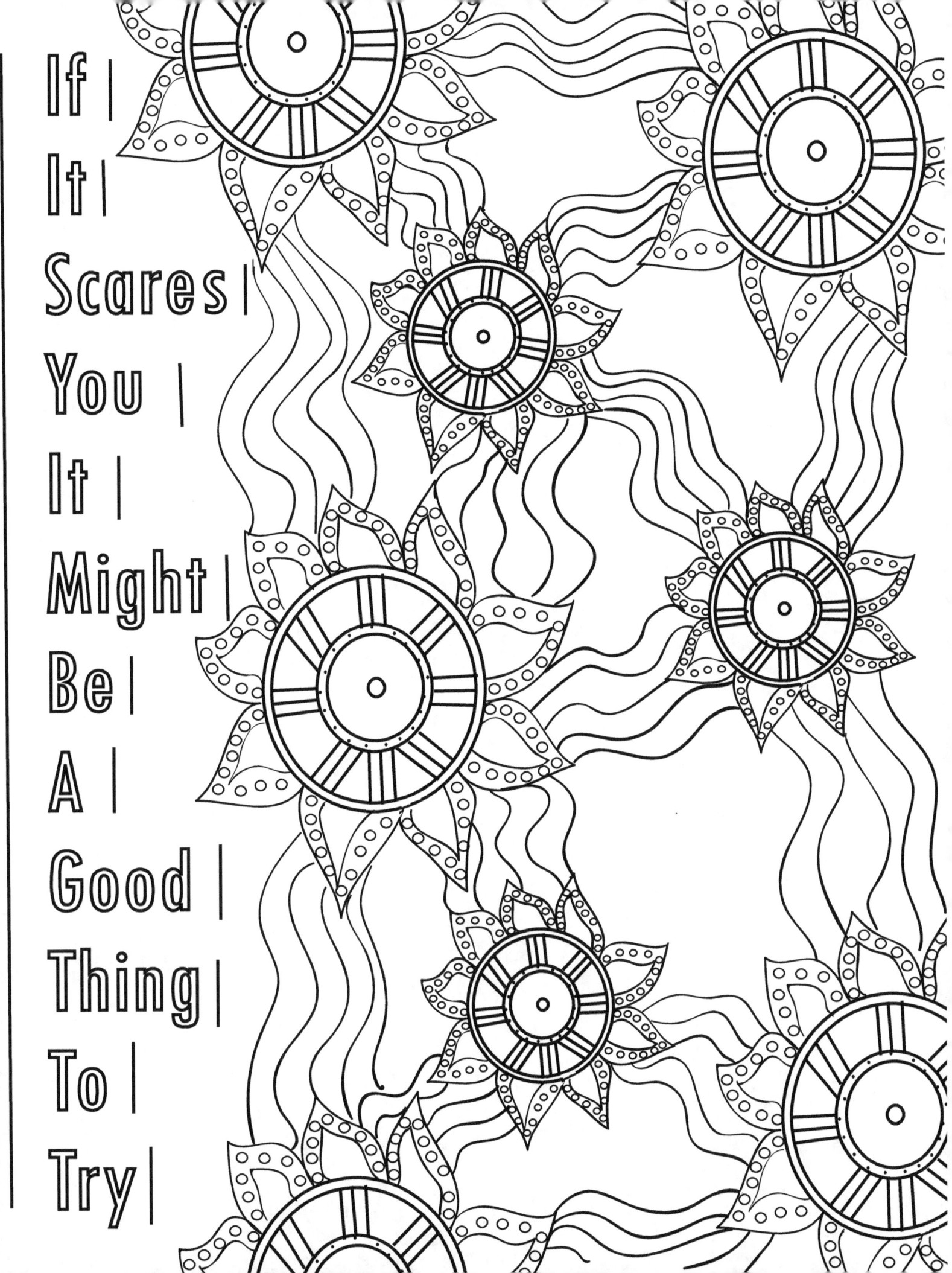

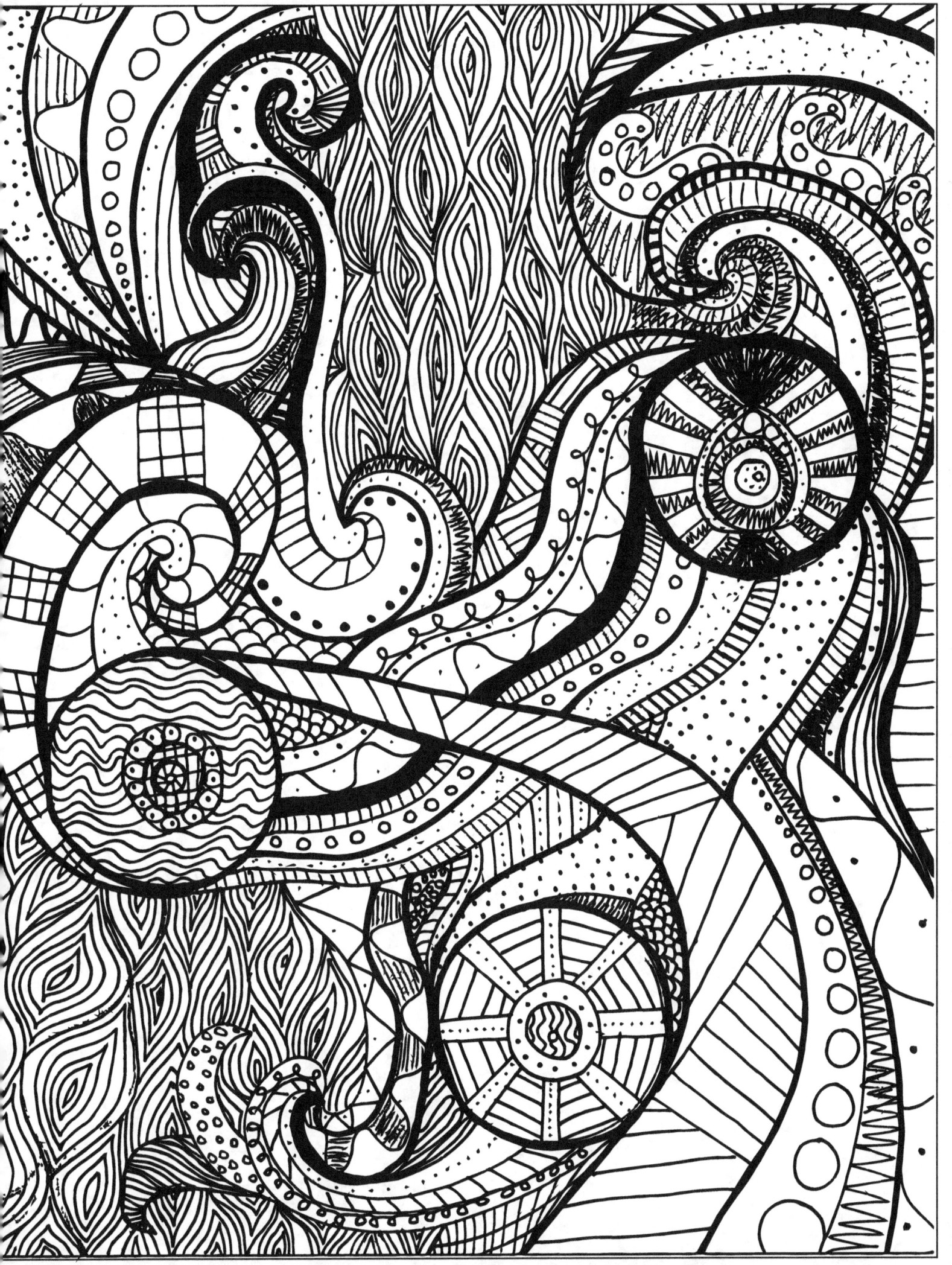

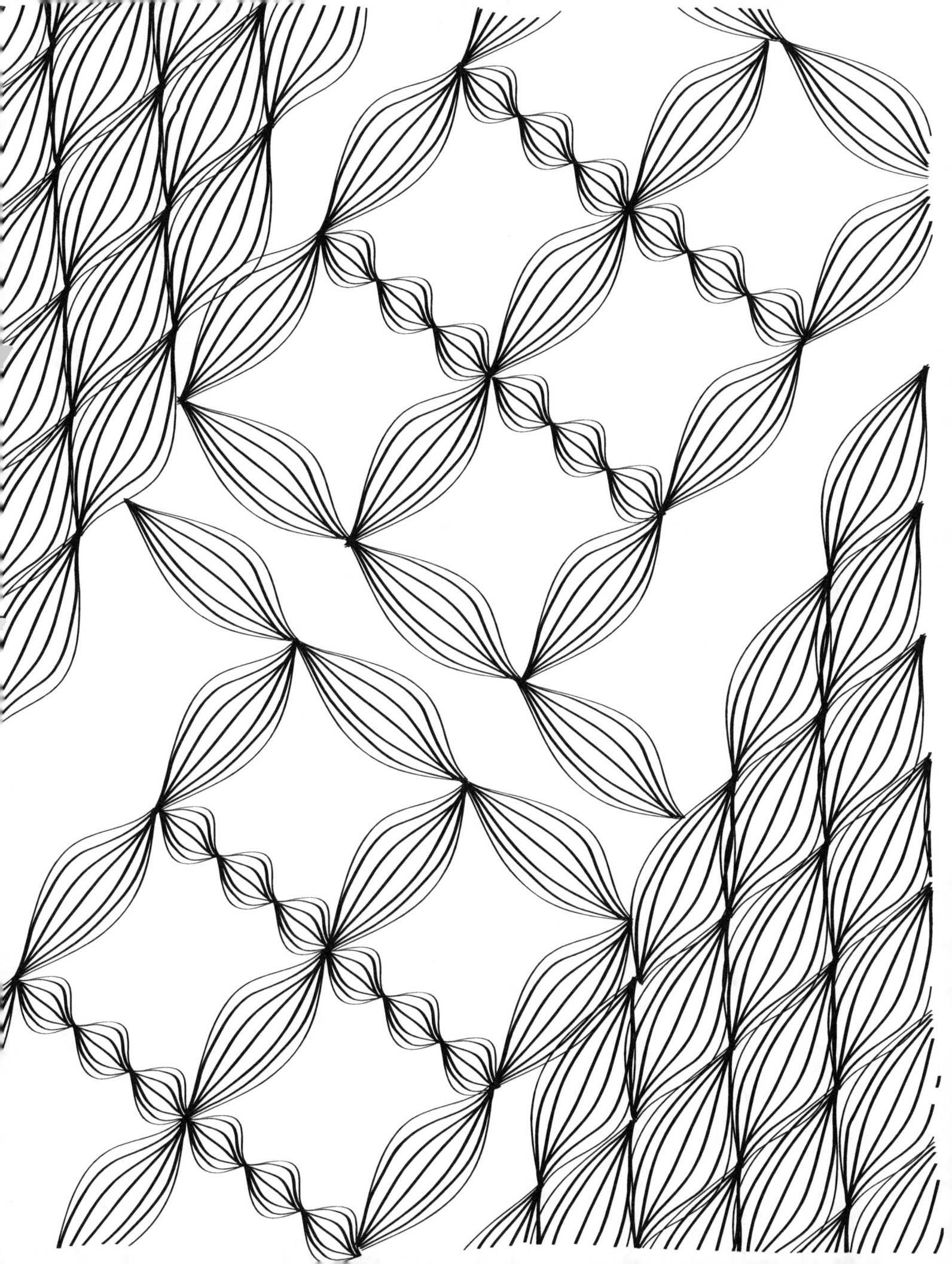

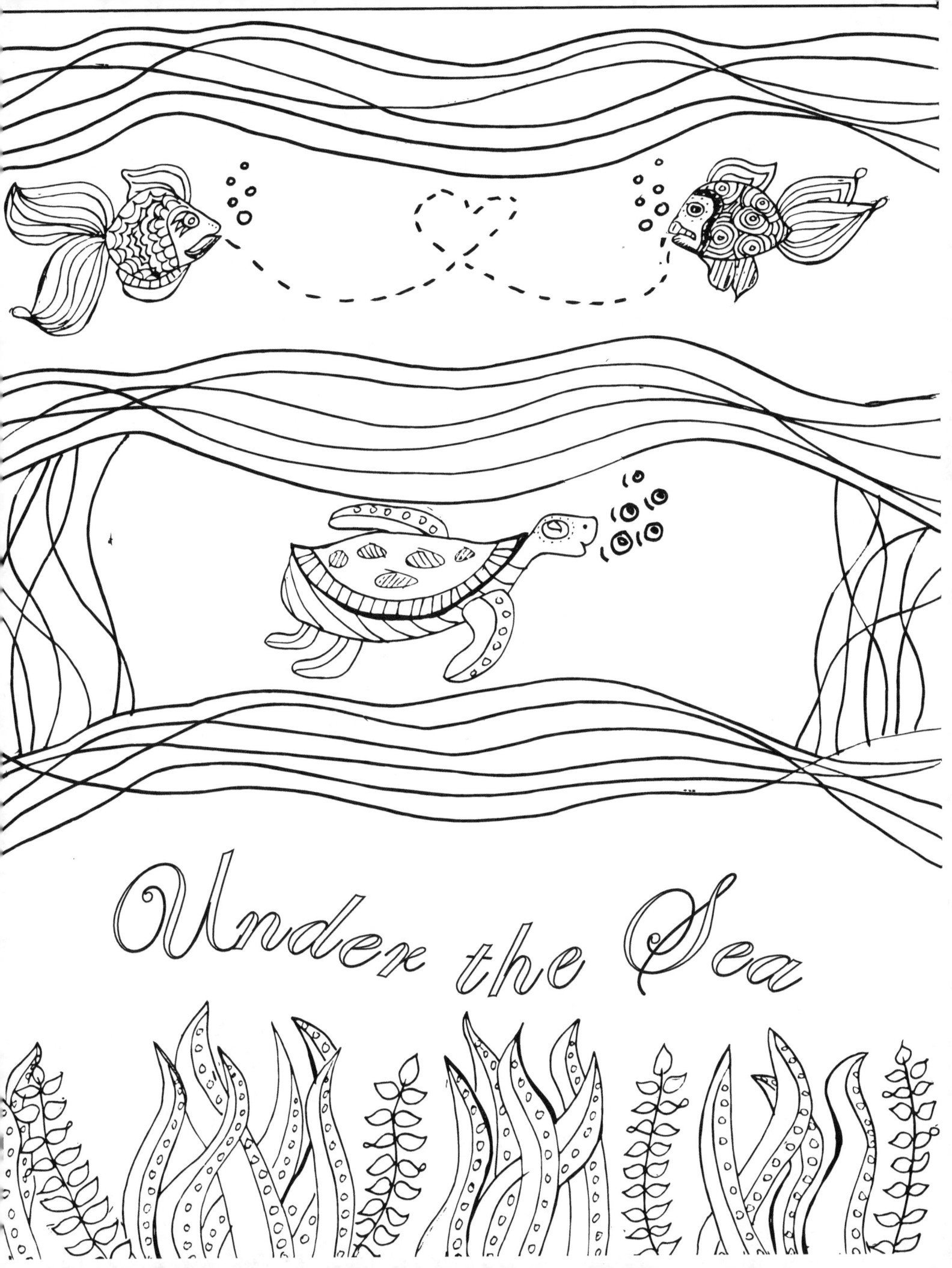

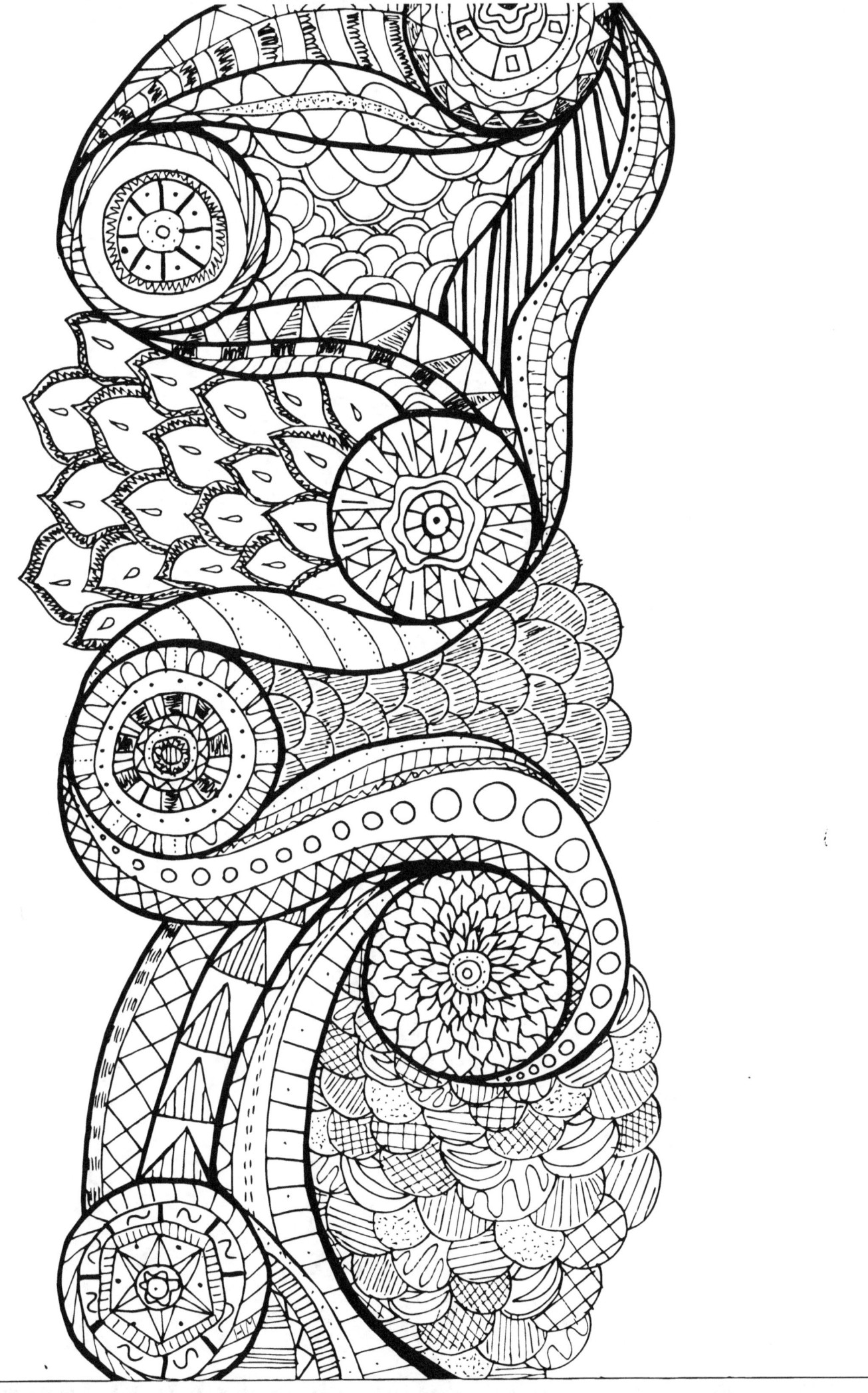

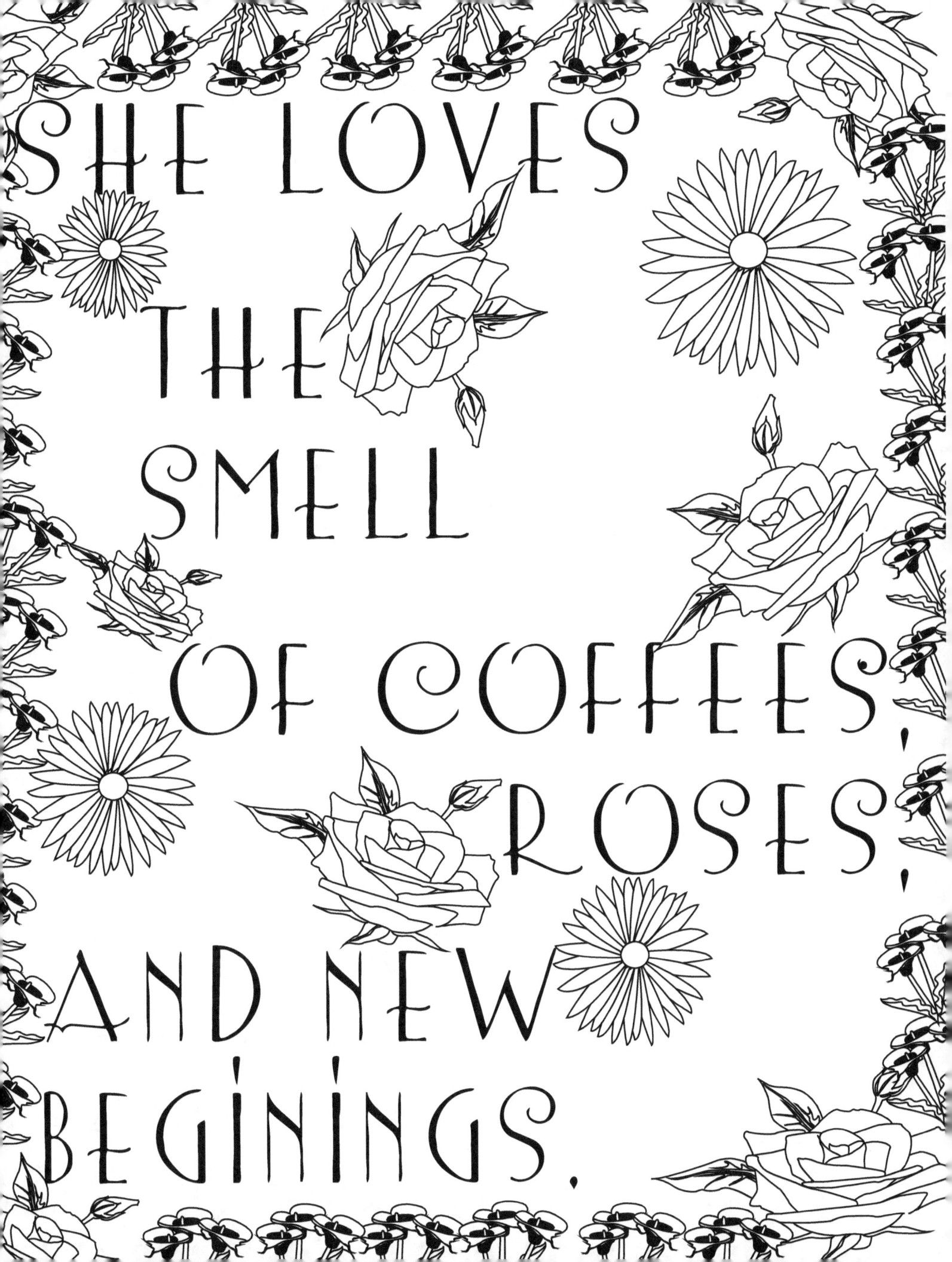

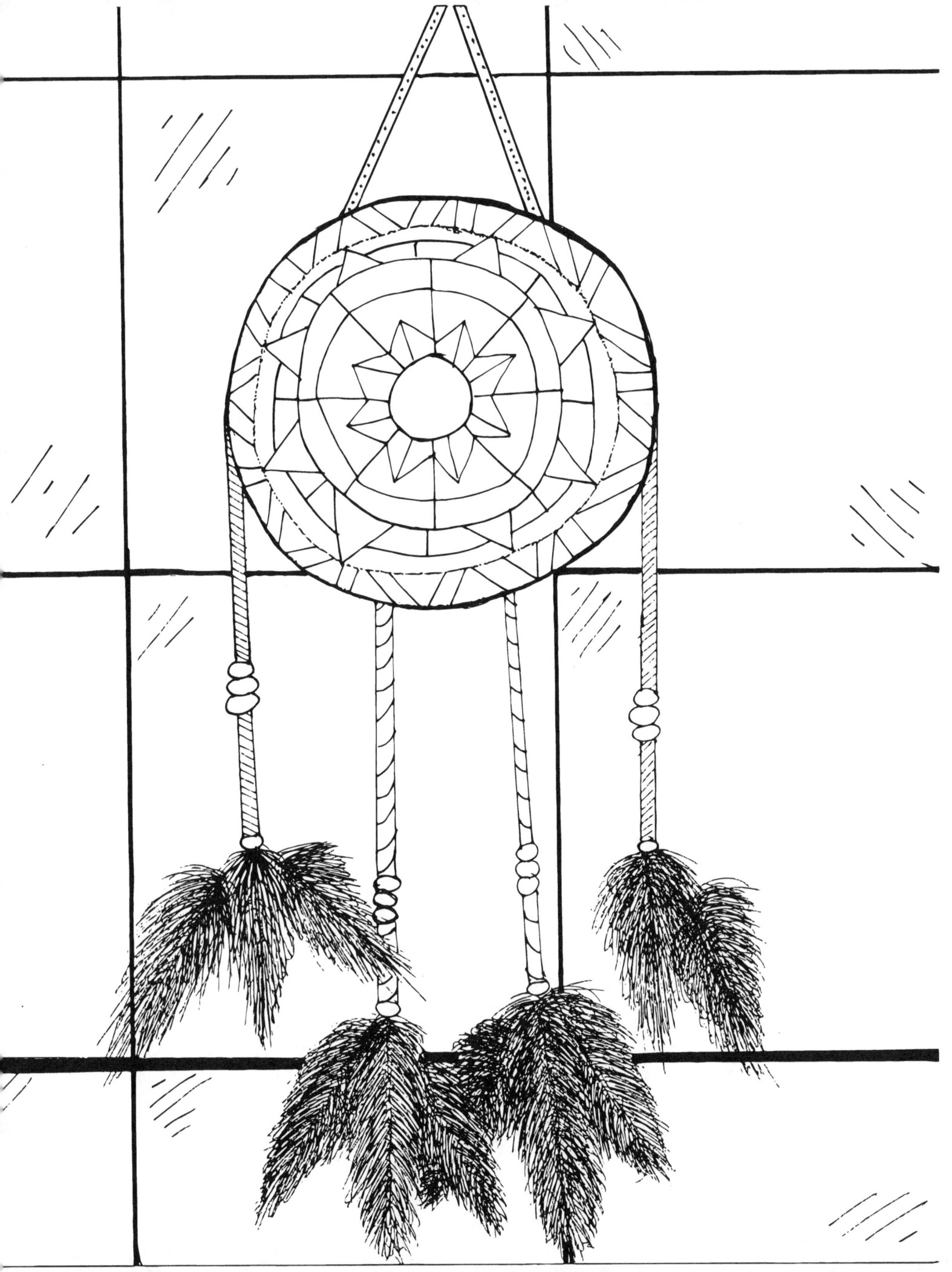

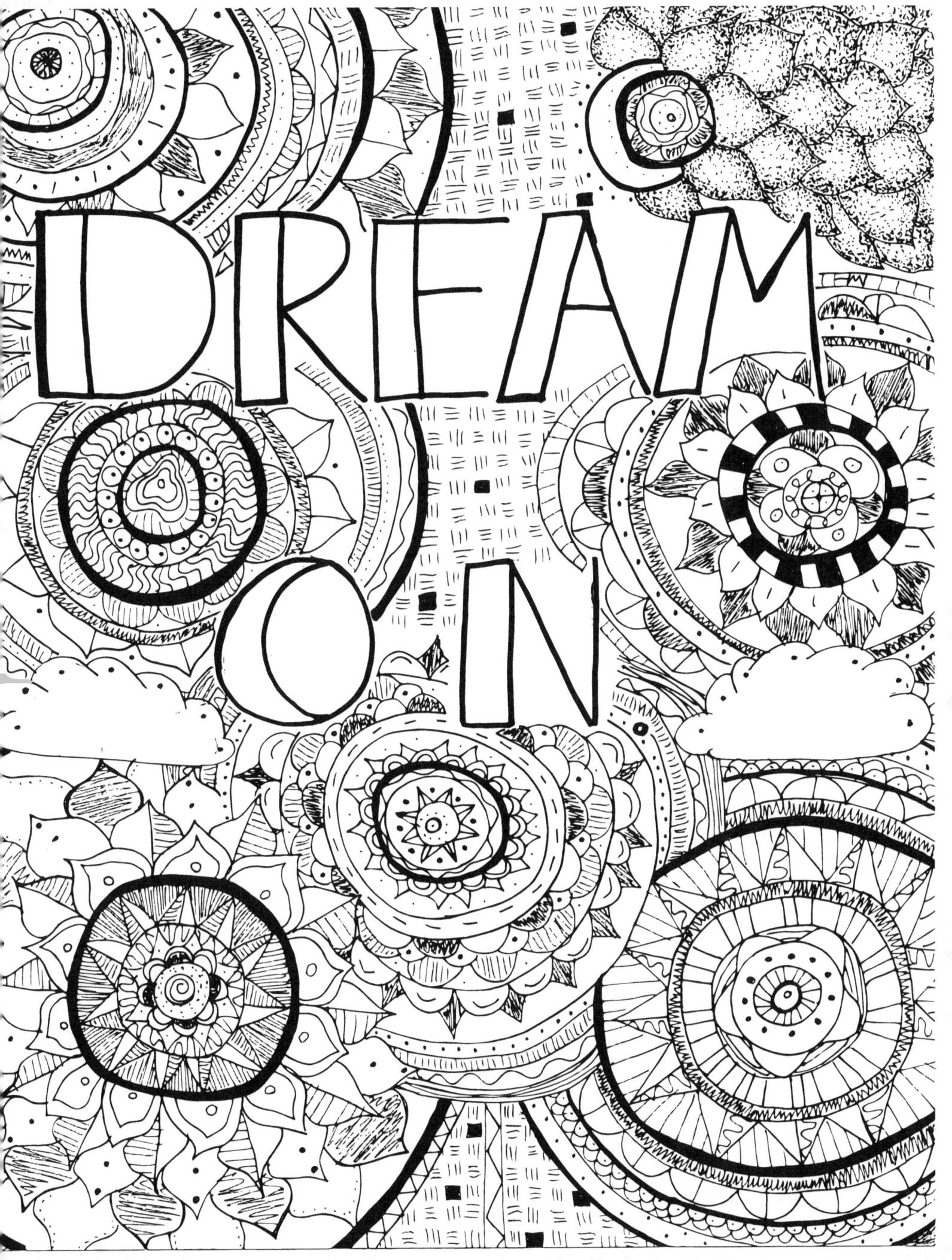

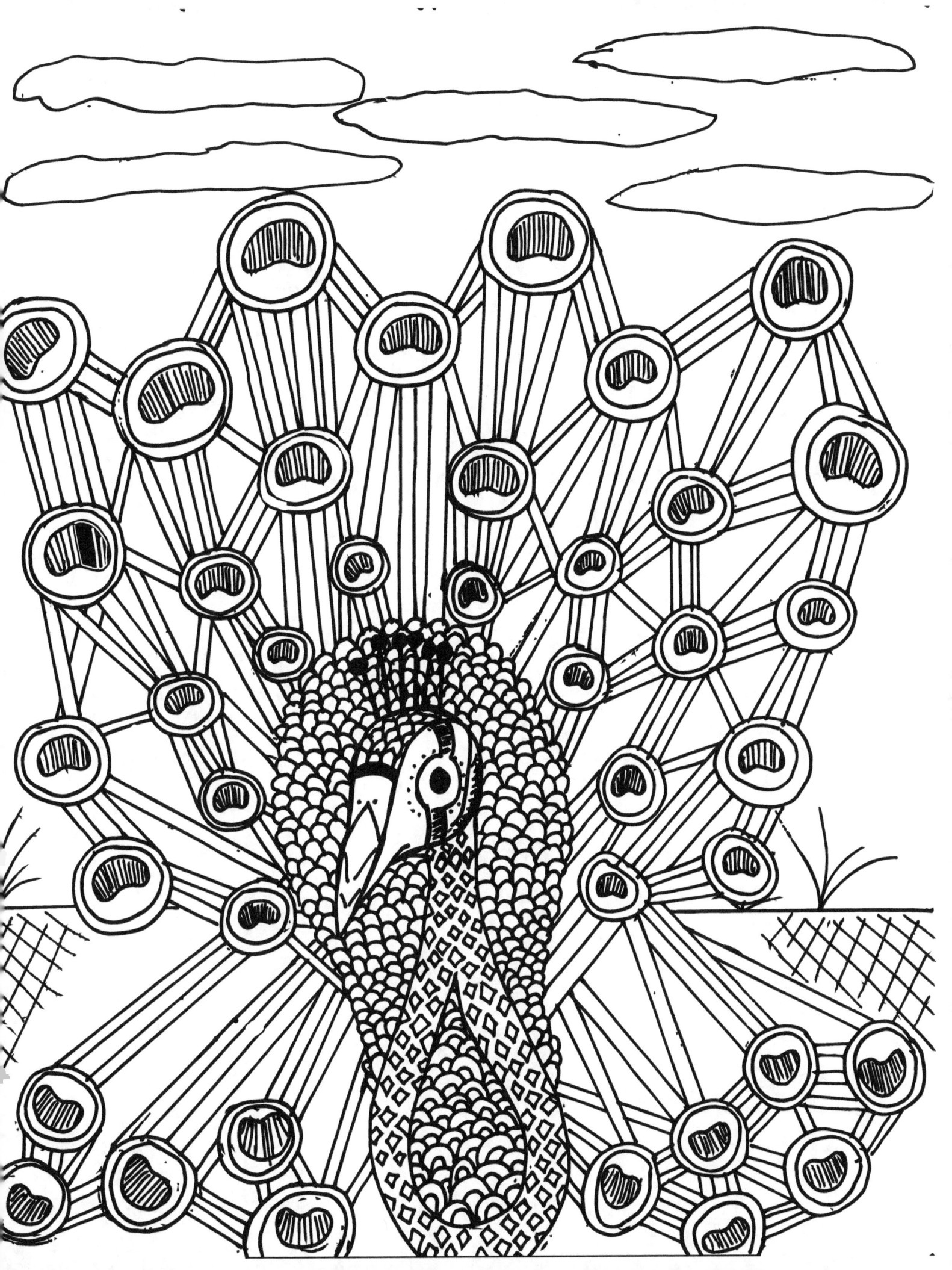

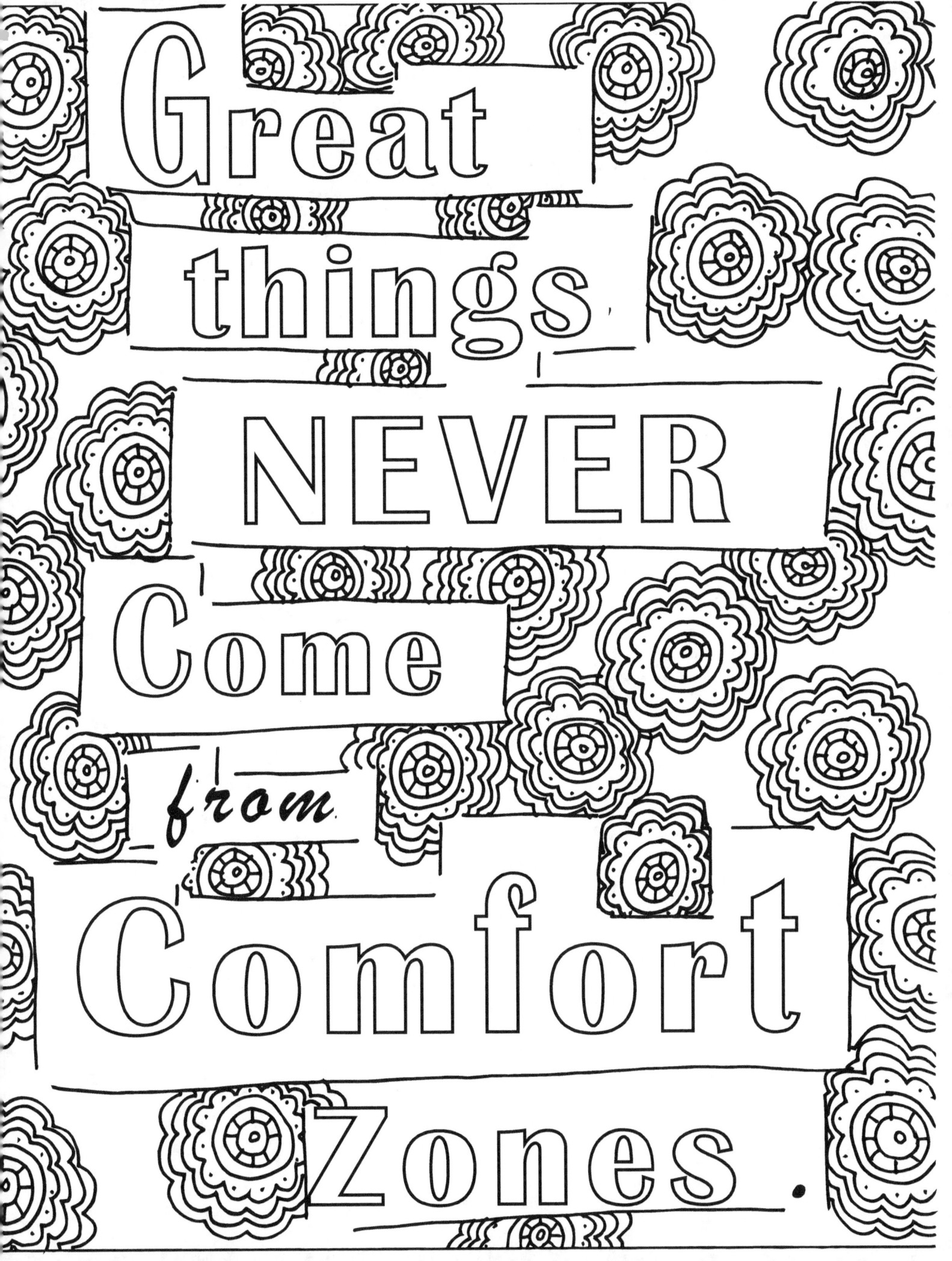

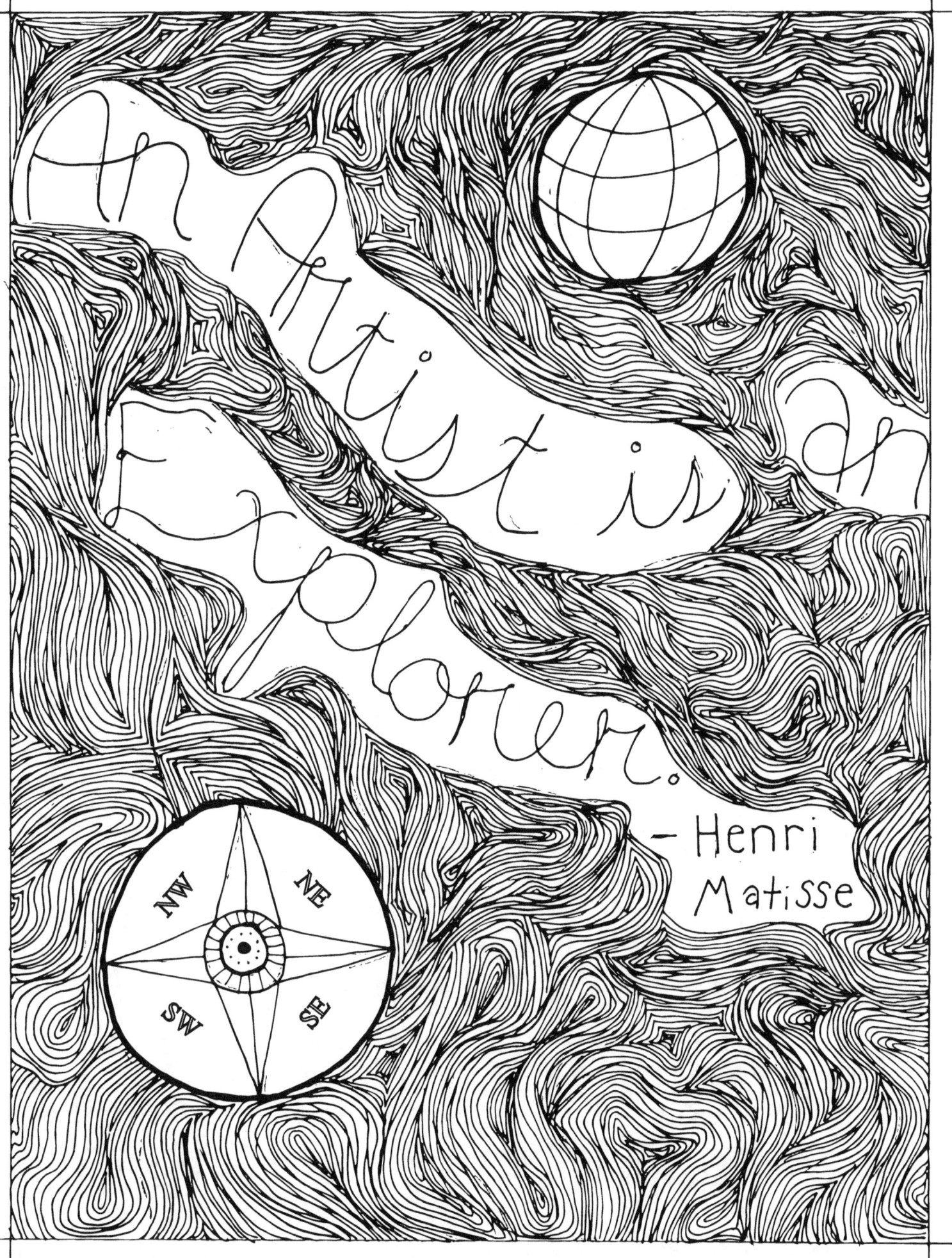

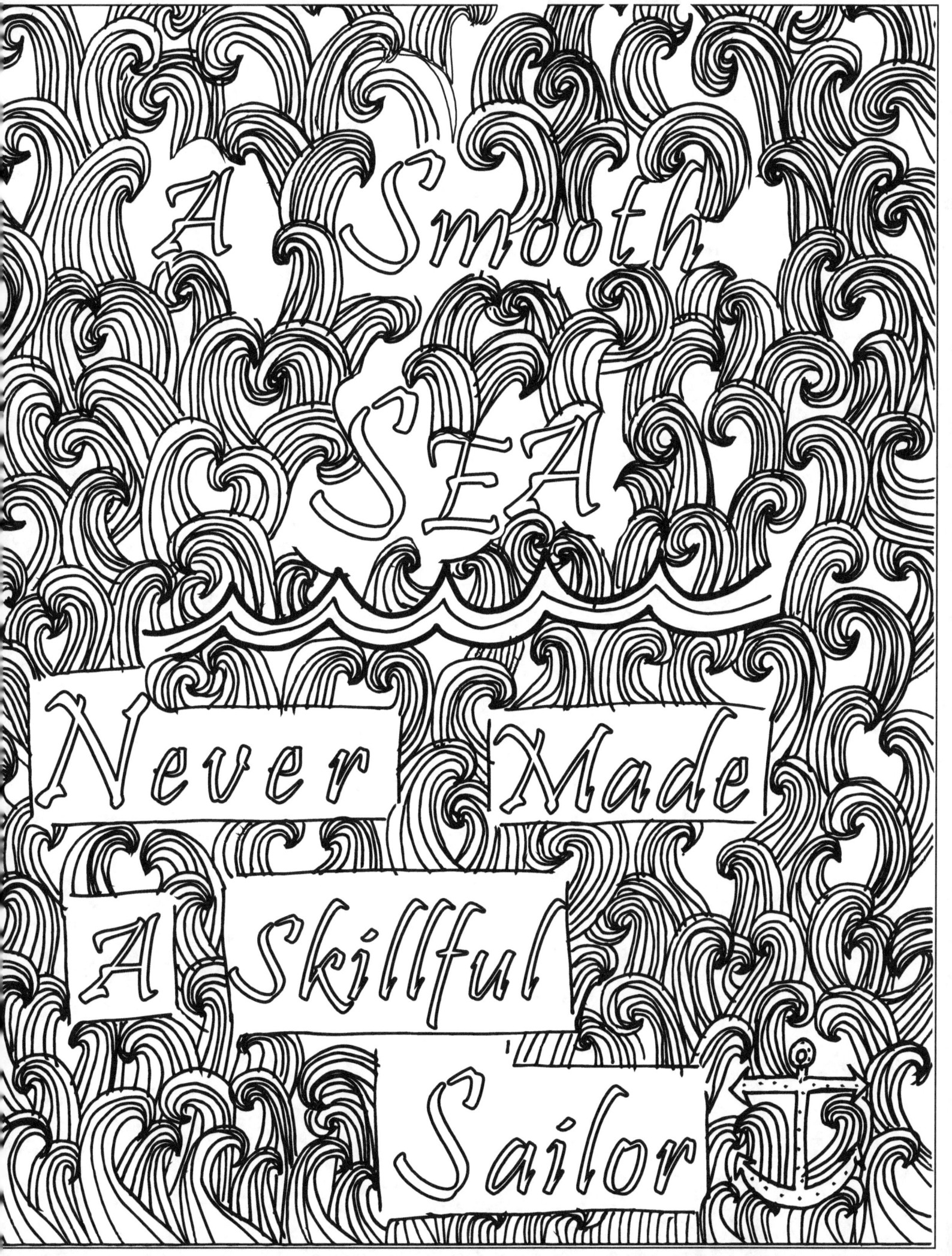

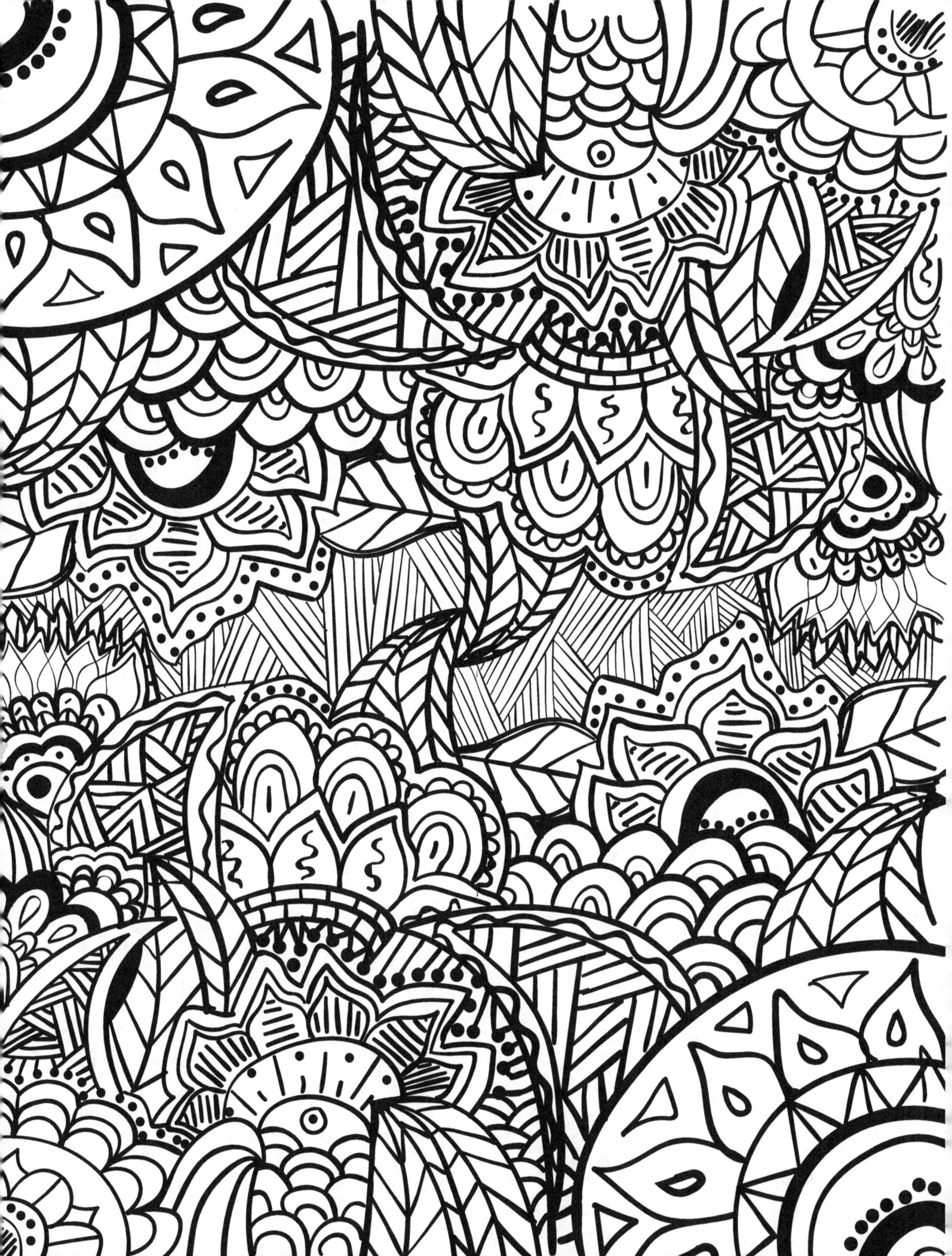

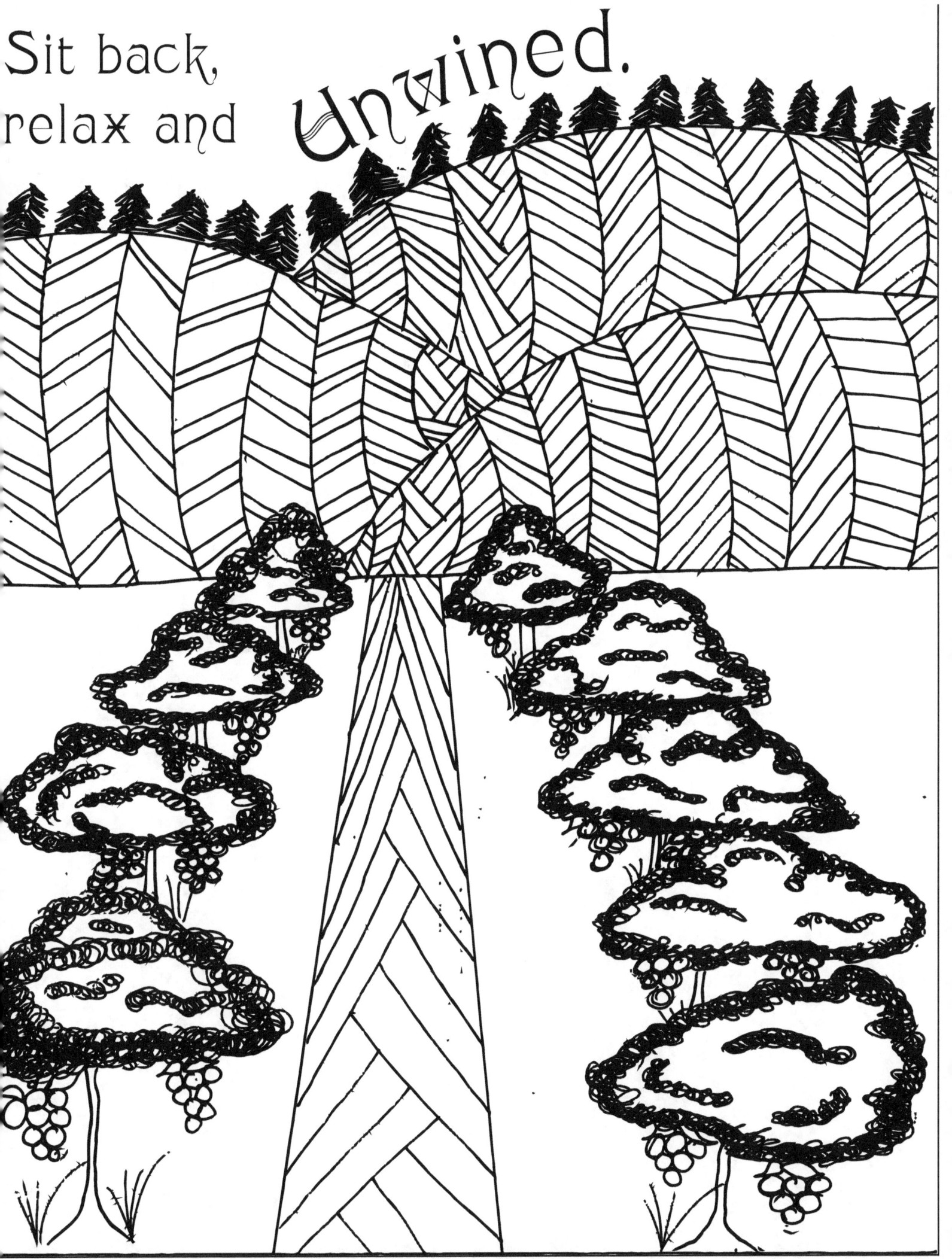

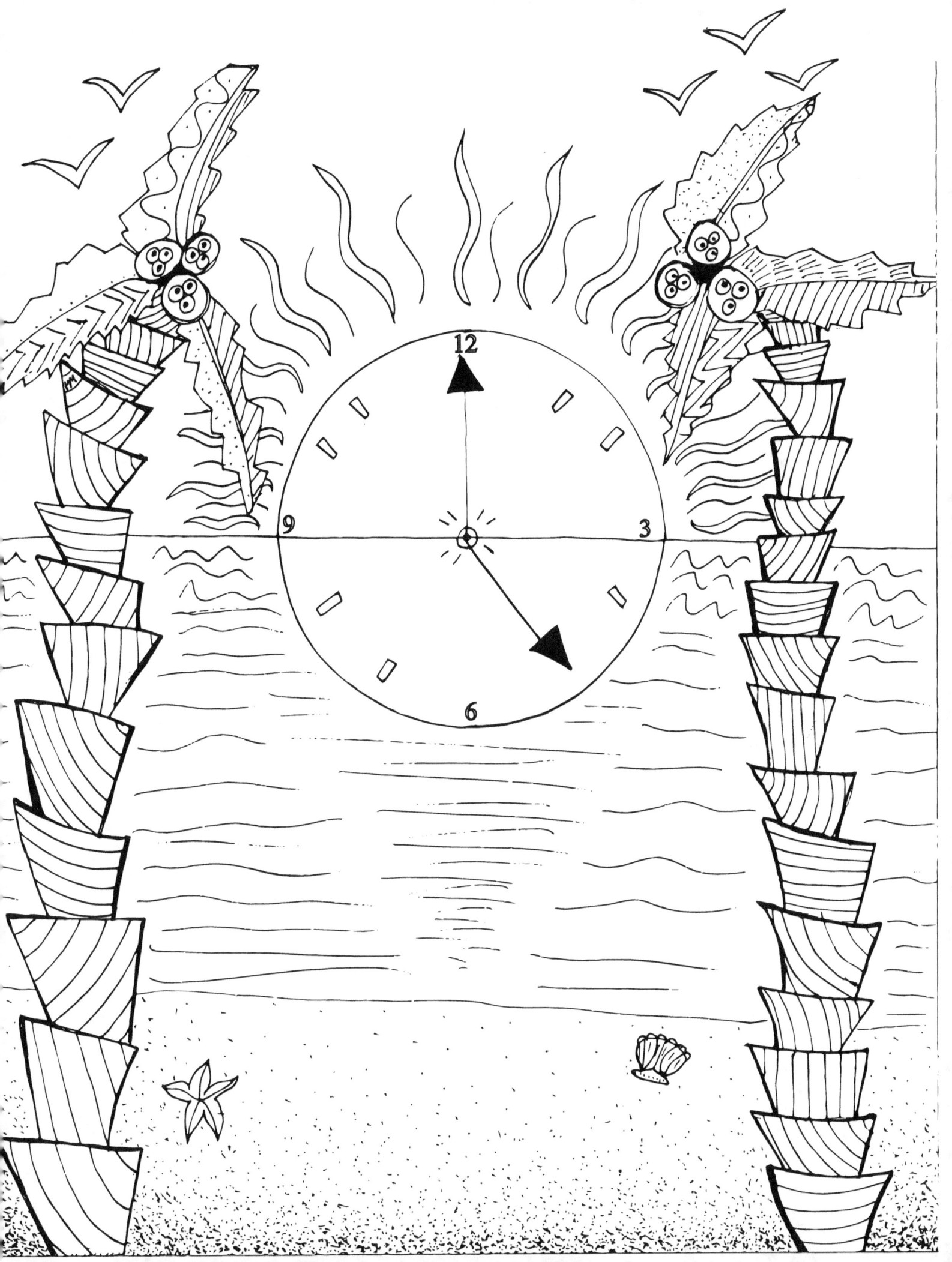

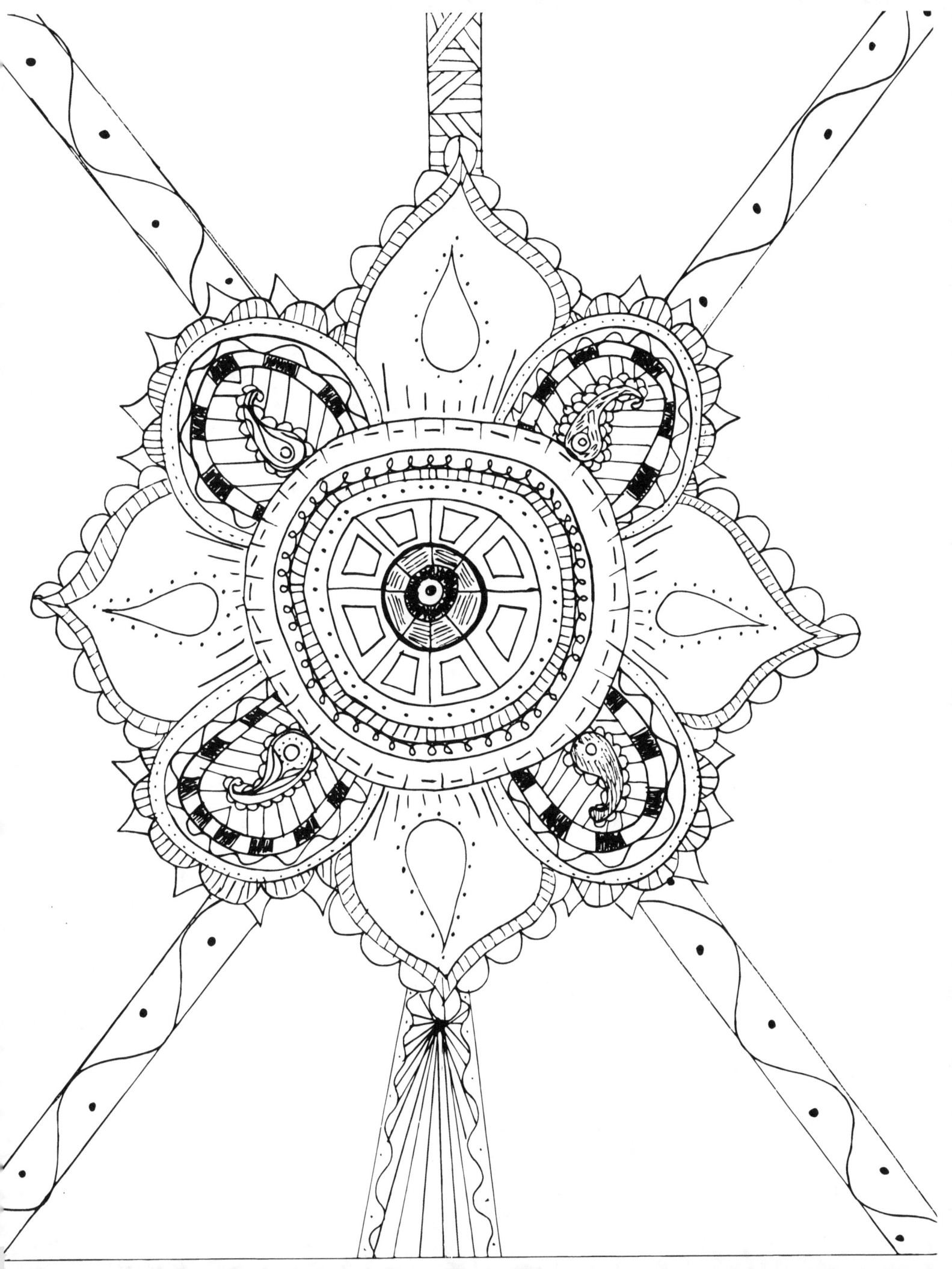

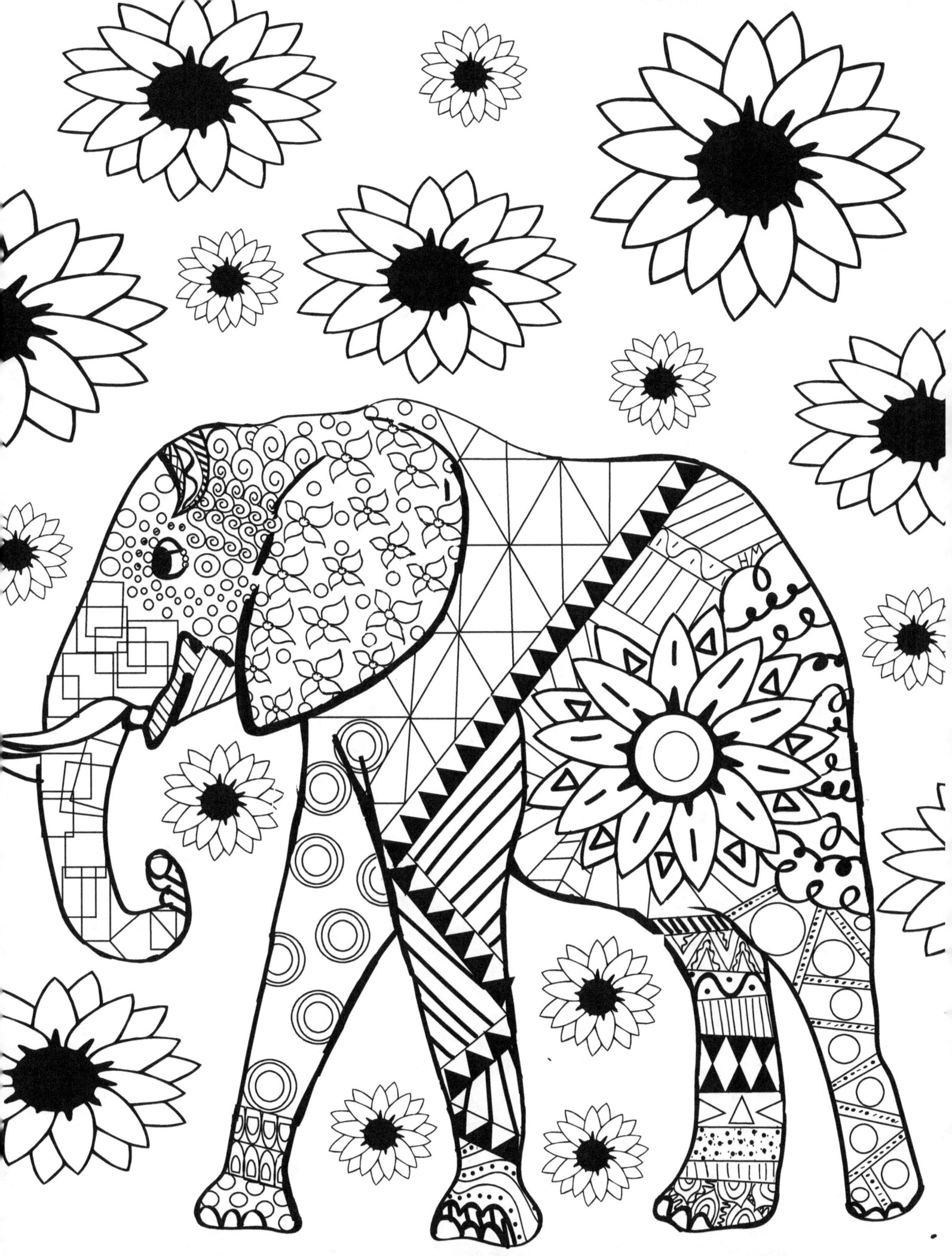

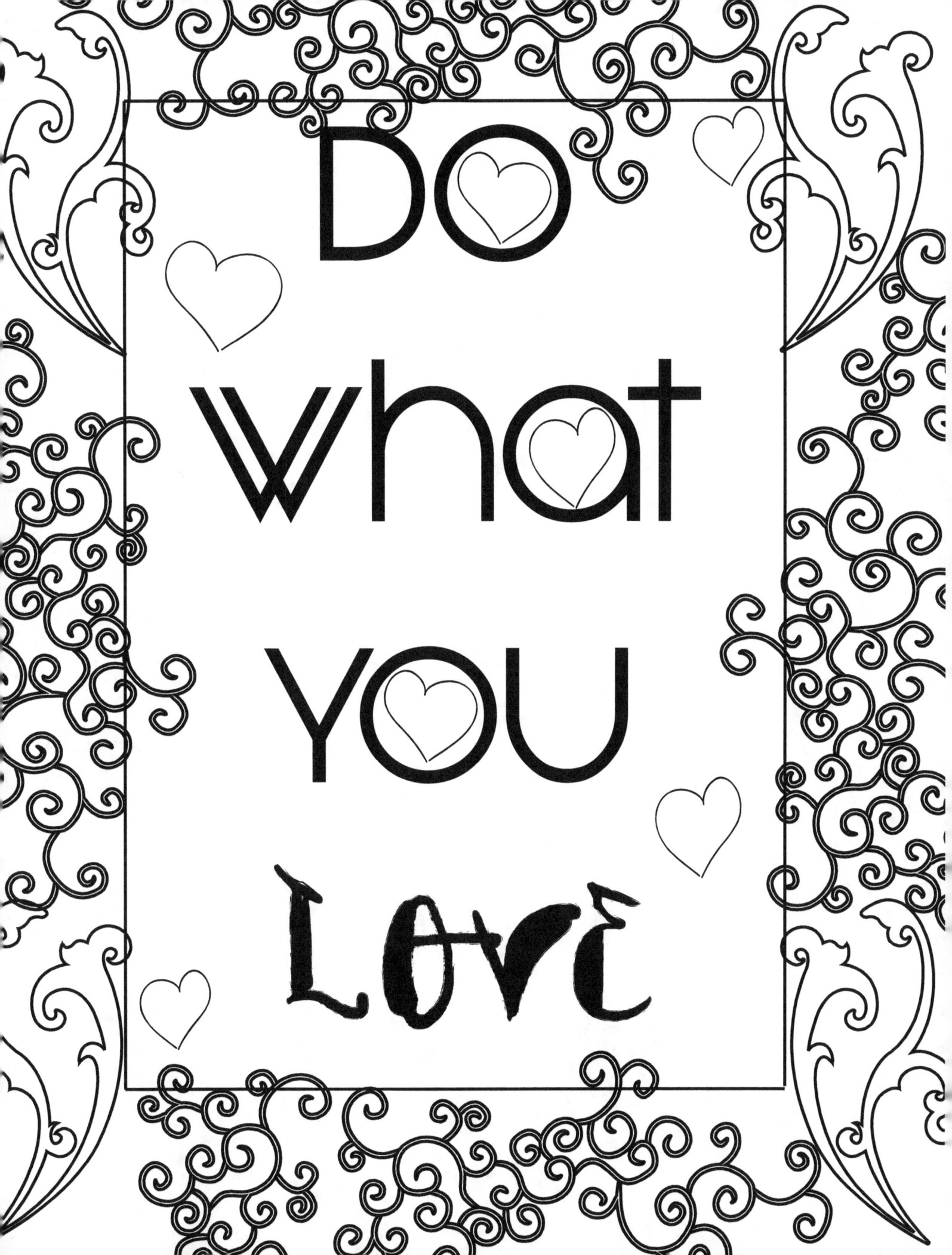

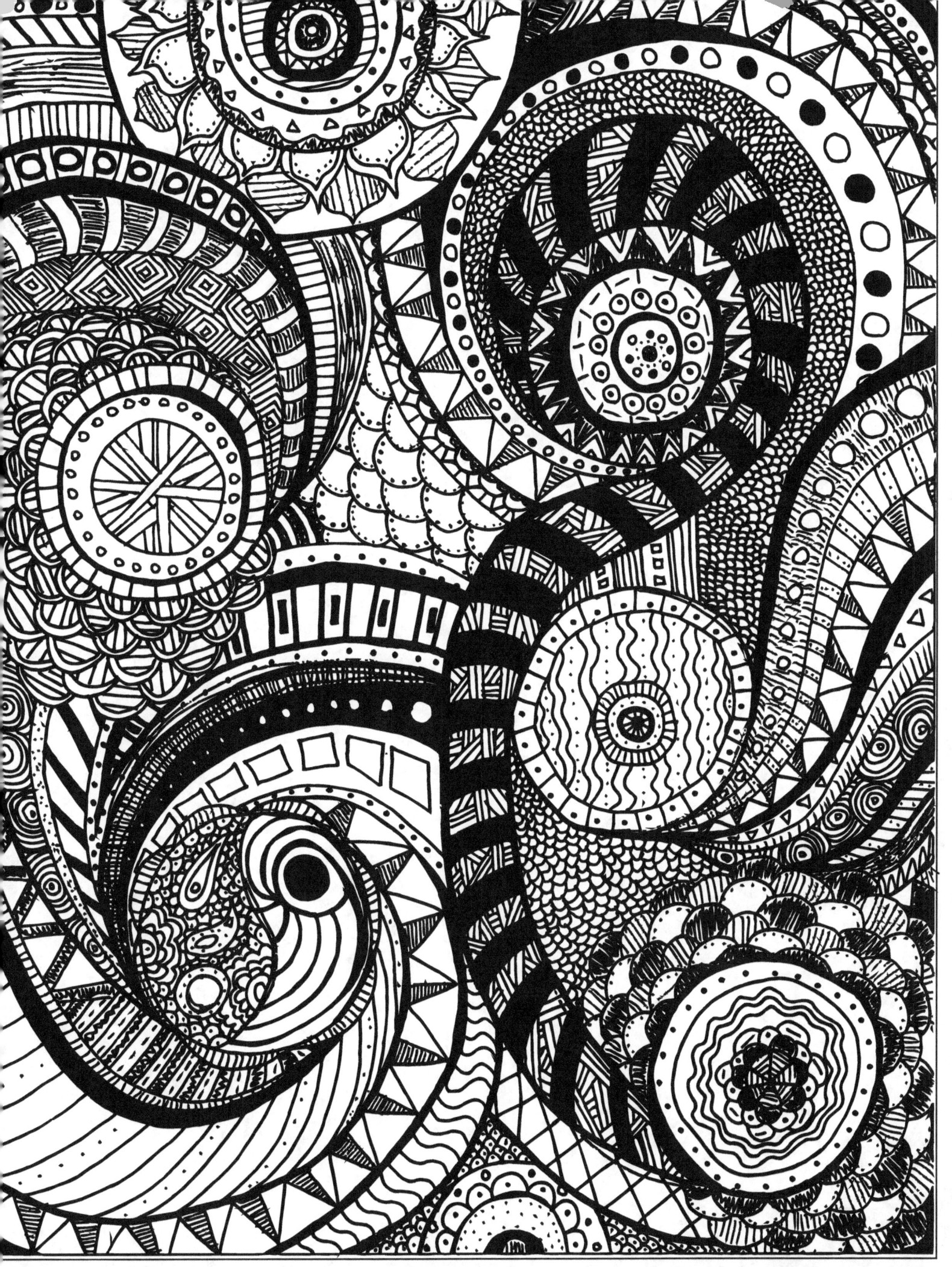

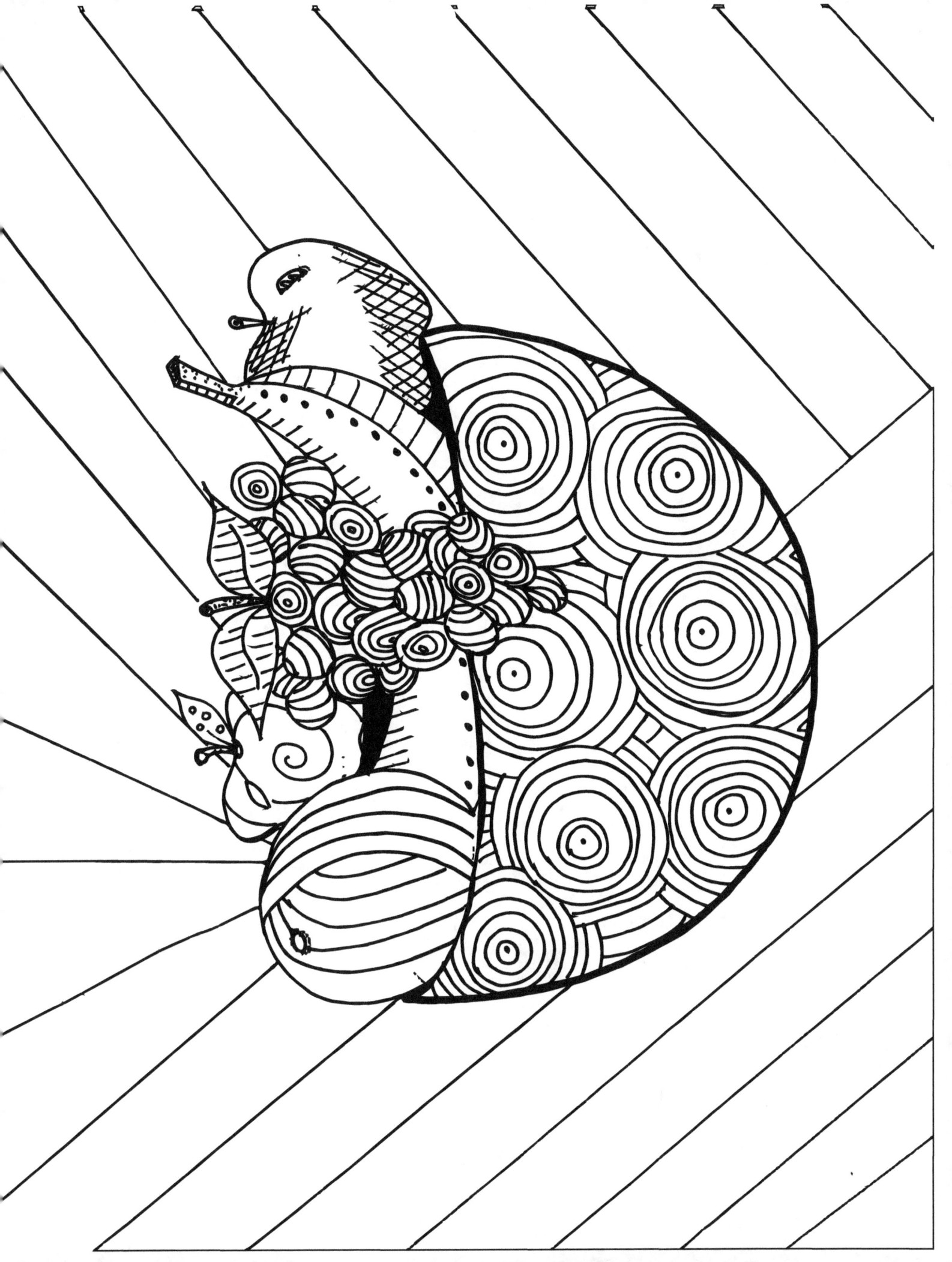

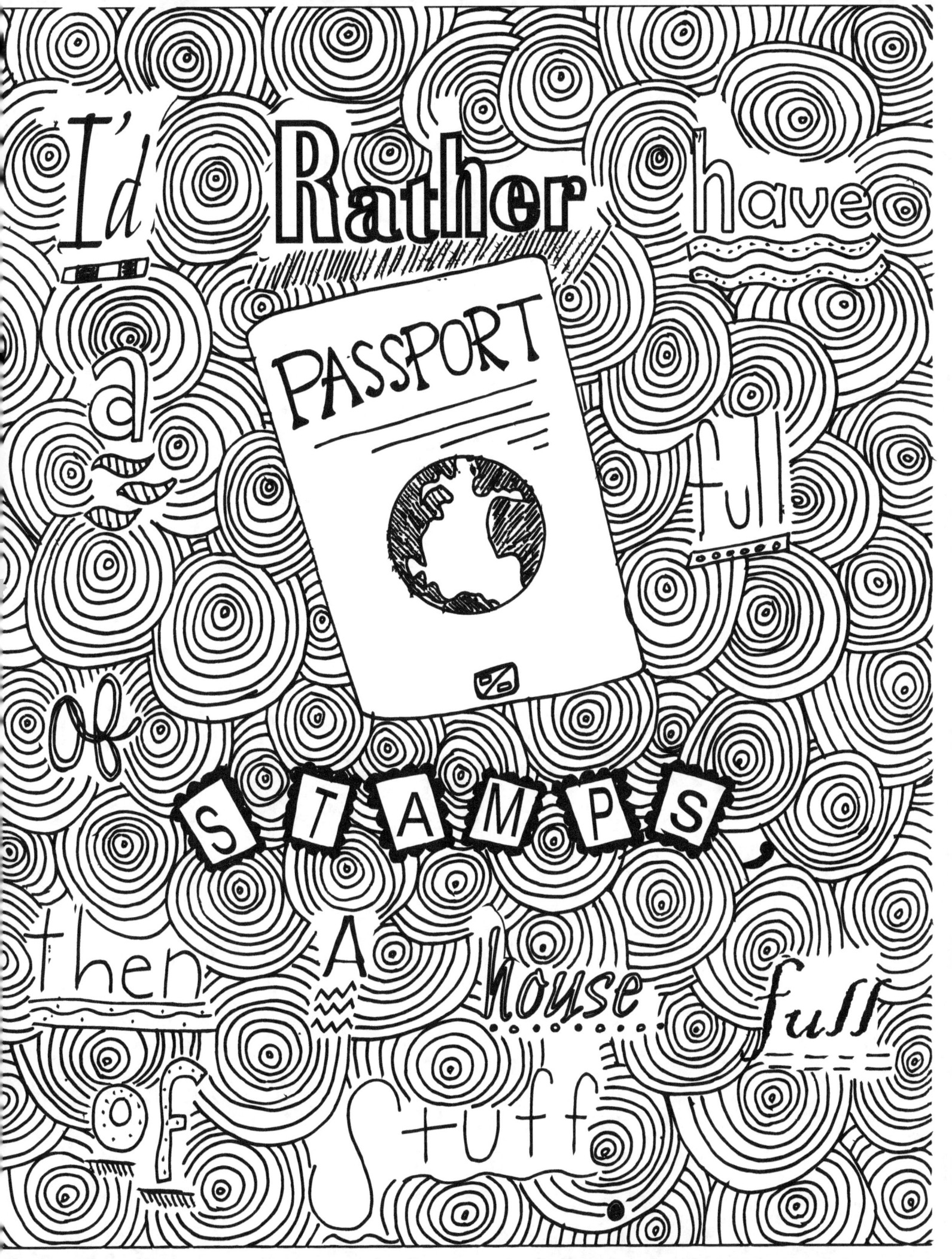

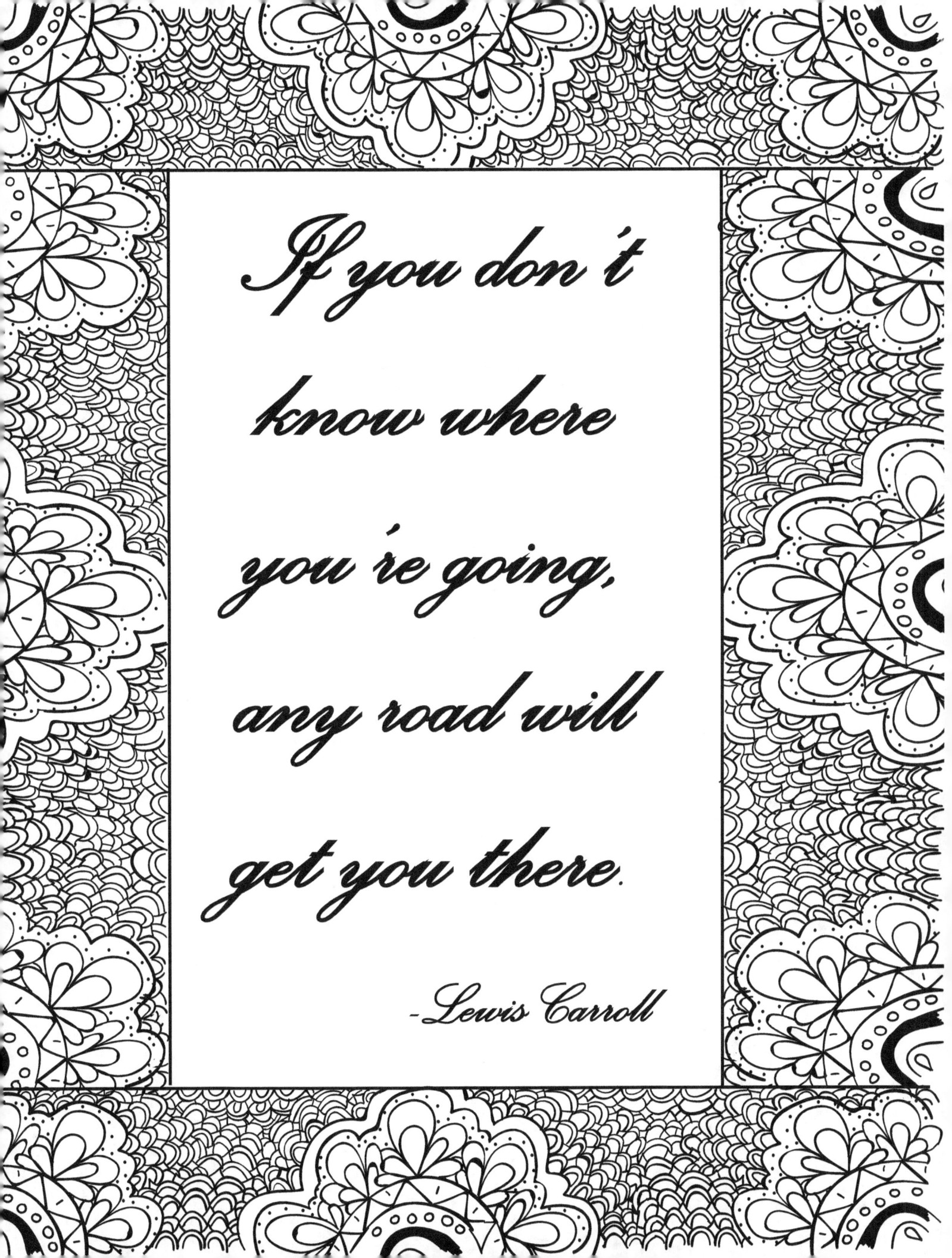

If you don't know where you're going, any road will get you there.

—Lewis Carroll

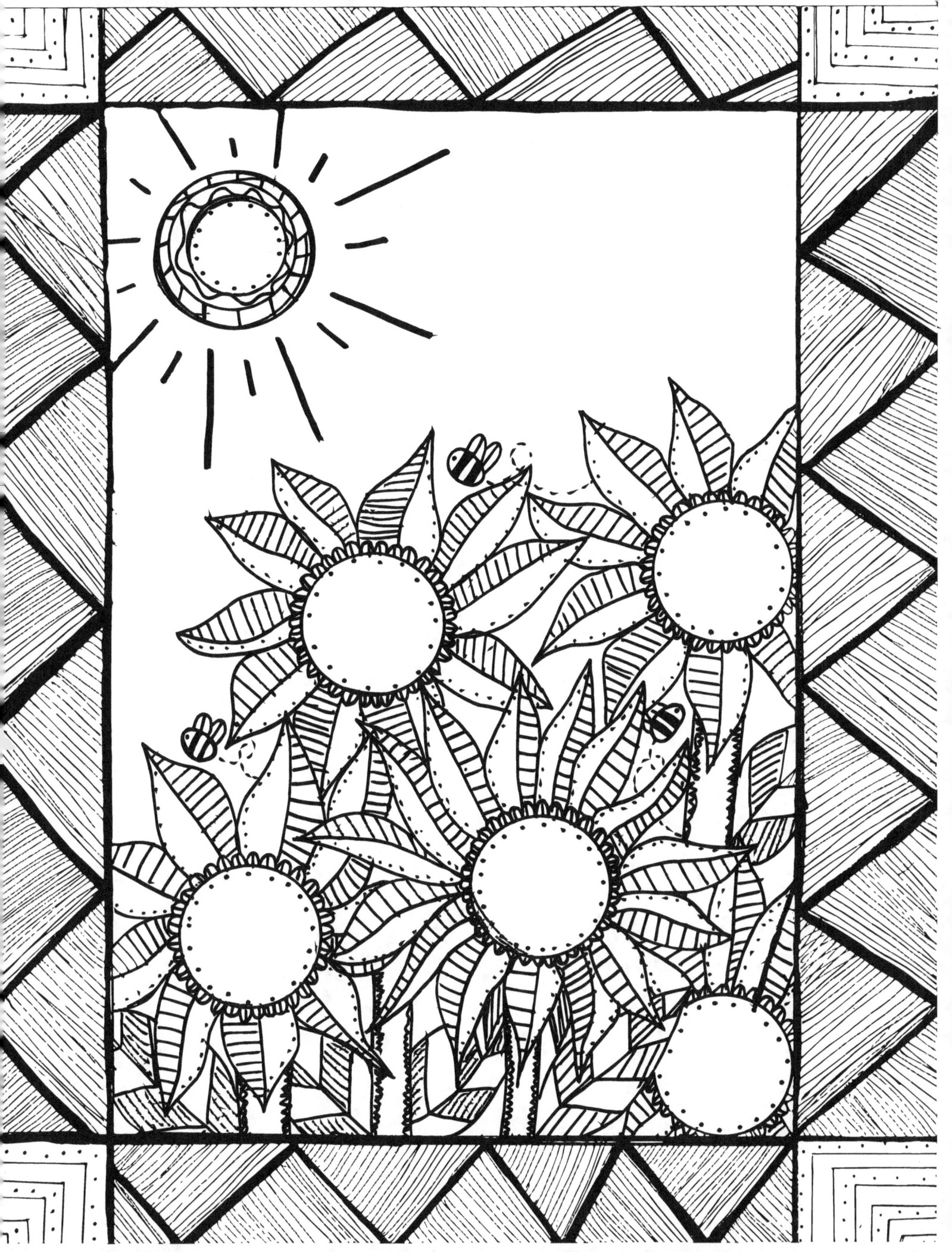